Serizawa

Master of Japanese Textile Design

Serizawa

edited by Joe Earle

with contributions by Kim Brandt, Matthew Fraleigh,
Shukuko Hamada, Terry Satsuki Milhaupt, Hiroshi Mizuo,
and Amanda Mayer Stinchecum

Japan Society, New York
Yale University Press, New Haven and London

"Serizawa Keisuke and Okinawa," by Amanda Mayer Stinchecum, copyright © 2009 by Amanda Mayer Stinchecum.

"Serizawa Keisuke: An Appreciation," by Hiroshi Mizuo, "The Art of Serizawa Keisuke," by Shukuko Hamada, "The Kataezome Technique," and "Chronology," all translated by Joe Earle.

With the exception of the lists of Japan Society friends and directors and the authors of essays, all Japanese personal names appear in traditional style, with family name preceding given name.

This volume accompanies the exhibition **Serizawa: Master of Japanese Textile Design,** presented at Japan Society Gallery, New York, October 9, 2009–January 17, 2010.

This exhibition is supported by the E. Rhodes & Leona B. Carpenter Foundation, Chris Wachenheim, the National Endowment for the Arts, The Coby Foundation, Ltd., Edward and Anne Studzinski, The Japan Foundation, The Blakemore Foundation, Furthermore: a program of the J. M. Kaplan Fund, and an anonymous foundation.

Media sponsorship is provided by

Transportation assistance is provided by

Exhibitions at Japan Society are also made possible in part by the Lila Wallace–Reader's Digest Endowment Fund and the Friends of the Gallery. Installations at Japan Society Gallery are supported by a generous gift from Henry Cornell.

Japan Society also wishes to thank The W. L. S. Spencer Foundation for its catalogue support.

Japan Society Gallery
333 East 47th Street, New York, NY 10017
WWW.JAPANSOCIETY.ORG

Yale

Yale University Press
P.O. Box 209040, New Haven, CT 06520–9040
YALEBOOKS.COM

Printed in Singapore.

Library of Congress CATALOGING-IN-PUBLICATION DATA
Serizawa, Keisuke, 1895–1984.
Serizawa : master of Japanese textile design / edited by Joe Earle ; with contributions by Kim Brandt ... [et al.]. — 1st ed.
 p. cm.
Published to accompany an exhibition held at the Japan Society Gallery, New York, Oct. 9, 2009–Jan. 17, 2010.
 Includes bibliographical references.
 ISBN 978-0-300-15047-6 (alk. paper)
 1. Serizawa, Keisuke, 1895–1984—Exhibitions. 2. Katazome—Exhibitions. I. Earle, Joe. II. Brandt, Kim. III. Japan Society (New York, N.Y.). Gallery. IV. Title.
NK8667.S47A4 2009
746.092—dc22 2009015962

A catalogue record for this book is available from the British Library.

This paper meets the requirements of ANSI/NISO Z 39.48–1992 (Permanence of Paper).

10 9 8 7 6 5 4 3 2 1

Book design and typesetting by Lucinda Hitchcock.
Typefaces: Chaparral and Belizio.

p. iii: fig. 25 (detail); p. viii: Serizawa Keisuke applying colors to a textile with the Mandala of the Four Seasons *(cat. 54), 1982; p. x: Serizawa Keisuke in the fabric-stretching yard of his workshop in Kamata, Tokyo, 1982; p. 92: cat. 22 (detail); p. 106: fig. 14; p. 124: cat. 38 (detail); p. 130: cat. 43 (detail); p. 132: cat. 60; p. 134: cat. 81 (detail)*

Contents

Foreword

Motoatsu Sakurai
President
Japan Society

Japan Society could not have presented this ambitious survey of the work of Serizawa Keisuke without the backing of many foundations and individuals. A two-year grant from the E. Rhodes & Leona B. Carpenter Foundation will help us meet the cost of this and two future shows. Chris Wachenheim and Edward and Anne Studzinski continue to display extraordinary personal generosity: we thank them once again for being such loyal members of the Japan Society family. This catalogue, the most comprehensive English-language publication devoted to Serizawa, is subsidized by a three-year grant from Jack and Susy Wadsworth through The W. L. S. Spencer Foundation. We have benefited once more from a grant by the National Endowment for the Arts and we also welcome The Coby Foundation, Ltd., as a new supporter of Japan Society. In addition, we offer sincere thanks to The Blakemore Foundation, The Japan Foundation, Furthermore: a program of the J. M. Kaplan Fund, and an anonymous foundation. We are indebted to Japan Airlines for their ongoing and critical help with transportation, and to our media partner WNYC New York Public Radio. Special mention should be made of the Friends of the Gallery, whose consistent support and encouragement remain so important to the realization of our long-term goals.

In Japan we especially appreciate the support of Hagino Kōki, president of Tōhoku Fukushi University, who not only granted Japan Society permission to display so many treasures from the Serizawa Keisuke Art and Craft Museum but also facilitated loans from many other institutions and private collectors. We owe an additional debt of gratitude to all the lenders, as well as to Serizawa Keiko, daughter-in-law of Serizawa Keisuke and deputy director of the Serizawa Keisuke Art and Craft Museum, and to her colleague Hamada Shukuko, professor at Tōhoku Fukushi University and curator of the museum. Ably assisted by Honda Akiko and Nara Aya, Ms. Hamada has been closely involved from the start with many aspects of the implementation of this exhibition.

I am delighted to note that *Serizawa: Master of Japanese Textile Design* is the one hundredth exhibition at Japan Society Gallery. As an artist who drew deeply on Asian tradition yet created work that expressed a global sensitivity, Serizawa perfectly symbolizes our commitment to artistic communication that transcends national boundaries. I congratulate the gallery on this impressive milestone and look forward with confidence to the next century of exhibitions.

M. Sakurai

Foreword

Kōki Hagino
President
Tōhoku Fukushi University
Director
Tōhoku Fukushi University
Serizawa Keisuke
Art and Craft Museum

I am delighted that we are able to hold this exhibition of the work of Serizawa Keisuke at Japan Society Gallery in New York.

One of Japan's greatest textile craftsmen, Serizawa Keisuke received two major awards from the Japanese government. In 1956 he was named Holder of an Important Intangible Cultural Property, a title better known outside Japan as Living National Treasure, and in 1976 he was appointed Member of the Order of Cultural Merit. The colorful artistry and boundless creativity of his work continue to delight his many admirers a quarter century after his death.

Serizawa's first exhibition outside of his native country took place in 1976–77 at the Grand Palais in Paris. This was followed by exhibitions in the United States, first in La Jolla (1979) and then in Riverside and at the Mingei International Museum in San Diego (1997–98). In Europe there have been shows at the National Museum of Scotland in Edinburgh (2001) and the Hermitage Museum in Saint Petersburg (2006), and in 1981 the French government appointed Serizawa Officier de l'Ordre des Arts et des Lettres. Thanks to these exhibitions and awards, his name has become widely known overseas as well as in Japan.

I hope that this exhibition, by bringing the beauty of Japanese textile art to the American public, will contribute to the further development of close and cordial relations between our two nations.

The Serizawa Keisuke Art and Craft Museum opened in 1989 on the campus of Tōhoku Fukushi

University. Serizawa Keisuke's son, Serizawa Chōsuke, himself a professor at our university, had previously presented the university with three thousand works by his father as well as a thousand pieces from his collection of folk crafts from around the world, creating the perfect opportunity for us to begin work on our own museum and thereby play a leadership role in the development of university museums in Japan. When the Serizawa Museum opened, Serizawa Chōsuke became its first director, and he continued to serve in this capacity until his death in 2006, laying the foundations for its success and overseeing the Riverside, San Diego, and Edinburgh exhibitions. No one would have been more pleased than he to know that the twentieth anniversary of his beloved museum is being marked by an exhibition of his father's work at New York's Japan Society Gallery.

It only remains for me to express my sincere gratitude to all those who have given this project such generous support and understanding.

Catalogue

1. Eggplants and Strawberries

1930, pair of hanging scrolls, stencil-dyed hemp
Overall size: 44⅜ × 15⅝ and 44⅛ × 15⅝ in.
(112.8 × 39.8 and 112 × 39.6 cm)
Serizawa Keiko Collection

Executed just two years after Serizawa first
encountered Okinawan textiles, these two
small studies are among his earliest essays
in the technique of stencil dyeing.

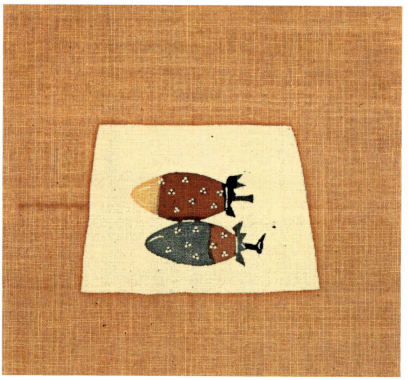

2. Chinese Cabbage

1978 (based on a design first executed in 1929),
partition hanging, stencil-dyed cotton
Overall size: 80¼ × 63¾ in. (204 × 162 cm)
Shizuoka City Serizawa Keisuke Art Museum

In 1929, Serizawa drew praise from two famous
ceramic artists, Tomimoto Kenkichi and Hamada
Shōji, for a prize-winning hand-painted wax-
resist wall hanging. Nearly half a century later, he
executed this copy of the design in his signature
kataezome technique. The original was Serizawa's
earliest major dyed textile work: looking back
he commented that "by using wax resist to apply
indigo pigment to a naturalistic botanical drawing,
I managed to capture, albeit distantly, the look
of ancient dyework."

3. Two Scenes from *Kojiki* (Records of Ancient Matters)

c. 1933, pair of hanging scrolls, stencil-dyed
hemp (Susanoo no Mikoto) and stencil-dyed
silk (Yamasachihiko)
Overall size of each: 48⅛ × 19½ in. (122.2 × 49.4 cm)
Shizuoka City Serizawa Keisuke Art Museum

For this pair of densely designed early figural com-
positions, one of the last works of his Shizuoka
period before he moved to Tokyo, Serizawa drew
on two episodes in the *Kojiki,* Japan's oldest his-
torical chronicle, compiled around 700. In the first
scene, the storm god Susanoo no Mikoto, expelled
from heaven for his violent behavior toward his
sister, Amaterasu the sun goddess, slays an eight-
headed dragon. Serizawa gives the storm god the
shape of a ceramic tomb-guardian figure known
as *haniwa,* made between the third and the sixth
centuries. In the second scene, the harvest god
Yamasachihiko sits astride a giant shark that was
the true form of his former wife, the daughter of
the dragon king of the sea.

4. Scenes from *Isoho Monogatari* (Aesop's Fables)

1935, four-leaf screen, stencil-dyed silk
Overall size: 59⅝ × 61⅜ in. (151.5 × 156 cm)
Tōhoku Fukushi University
Serizawa Keisuke Art and Craft Museum

Aesop's fables have been known in Japan since the surprisingly early date of 1593, when the Jesuit mission press published a version in romanized Japanese. A Japanese-script edition of the text appeared a few years later, and the first of several premodern illustrated versions was printed in 1659. Sixteen of Serizawa's Aesop designs were originally executed in scroll format and shown at a folk-craft exhibition in 1932, while the first record of an Aesop screen appears in the catalogue of an exhibition held by Serizawa after he moved to Kamata in March 1934. The roundel designs, somewhat less stylized than the two *Kojiki* episodes (see cat. 3), can be seen as a precursors to Serizawa's much more ambitious foray into European literature, *Ehon Don Kihōte* (see cat. 9).

5. Japanese Syllables

1940, eight-leaf screen, stencil-dyed
tsumugi-weave silk
Overall size: 60 × 121¼ in. (152 × 308 cm)
Japan Folk Crafts Museum

This is Serizawa's first large-scale design based on the forty-seven graphs of the cursive Japanese phonetic script known as hiragana. Read downward from the right in columns, the syllables are arranged in the same traditional order as in an ancient poem that uses each of them once only, starting, *i, ro, ha, ni, ho, he, to, chi,* and *ri.* They are alternated with images of objects whose names begin with the same syllable: *iori* (hut), *rōsoku* (candle), *hagoita* (a decorative racket used in New Year's games), *nishikide* (enameled decoration on porcelain), *hobune* (sailboat), *heishi* (sake jar), *toishi* (grindstone), *chasen* (tea whisk), and *rin* (bell). Many of the subsequent references similarly reflect Serizawa's detailed knowledge of unusual traditional artifacts. For other treatments of the Japanese syllabary, see catalogues 55, 60, 75, and 100. The subsequent graphs are:

nu	*nuno* (cloth)	**na**	*nagaya-mon* (the gateway to a samurai mansion)	**ke**	*kera* (straw raincoat worn in northeastern Japan)	**mi**	*mi* (winnowing tray)
ru	*ruriyū* (lapis-lazuli-colored glaze)	**ra**	*raden* (mother-of-pearl decoration)	**fu**	*fukuro* (bag)	**shi**	*jō* (lock, traditionally written with the syllables *shi [ji]-yo*)
(w)o	perhaps *omodaka* (a water plant)	**mu**	*mushikago* (insect cage)	**ko**	*koma* (top)	**(w)e**	*eri* (collar of a kimono)
wa	*wan* (bowl)	**u**	*uchiwa* (nonfolding fan)	**e**	*eboshi* (courtier's cap)	**hi**	*hikite* (furniture handle)
ka	*kagami* (mirror)	**i**	*igeta* (frame around a wellhead)	**te**	*te* (hand)	**mo**	*mokoshi* (bracket)
yo	*yoroi* (armor)	**no**	*nomi* (chisel)	**a**	*ōgi* (folding fan, traditionally written with the syllables *a-fu-gi*)	**se**	*zen* (tray)
ta	*taru* (bucket)	**o**	*oke* (bucket)	**sa**	*sakazuki* (sake cups)	**su**	*suzuri* (stone for grinding ink)
re	*renge* (lotus)	**ku**	*kushi* (comb)	**ki**	*kyōsoku* (elbow rest)		
so	*some* (dyeing)	**ya**	*ya* (arrow)	**yu**	*yutō* (hot-water jug)		
tsu	*tsuchi* (mallet)	**ma**	*magemono* (bentwood box)	**me**	*megane* (spectacles)		
ne	*nenju* (the act of using a Buddhist rosary)						

6. Papermaking Village in Ogawa

1943, kimono, stencil-dyed crepe silk
61¾ × 48¼ in. (156.8 × 122.6 cm)
Tōhoku Fukushi University
Serizawa Keisuke Art and Craft Museum

The fine detail of this kimono, which seems almost to defy the limitations of stencil dyeing, demonstrates the great technical strides that Serizawa had made since his first efforts to revive the process in about 1930 and reflects the technical expertise he had absorbed during two visits to Okinawa in 1939 and 1940 (see cat. 26 and the essay by Amanda Mayer Stinchecum in this catalogue). The subject matter expresses a growing interest during the 1930s in regional craft traditions, in particular folk kilns (*min'yō*), textiles, and papermaking. Inspired by Yanagi Muneyoshi, founder of the mingei movement, Serizawa sketched regional ceramic centers in 1933, then in 1935 he began teaching paper dyeing and design at the Prefectural Papermaking Institute in Ogawa, Saitama Prefecture; in November 1935, an issue of Yanagi's *Kōgei* magazine was devoted to Japanese papermaking. In addition to the present kimono, six larger compositions exhibited in 1938 (see cat. 56) were inspired by Serizawa's experiences in Ogawa. To build up the pattern of papermaking scenes into a continuous design, the stencil was used on both sides.

7. *Katazomechō* (Album of Stenciled Designs)

Summer 1939, stencil-dyed cloth
11¾ × 4⅞ in. (29.7 × 12.4 cm)
Shizuoka City Serizawa Keisuke Art Museum

This experimental album, produced at Serizawa's Kamata studio in a limited edition of five and featuring a range of different fabrics, shows his increasingly subtle use of the stencil-dyeing process following his visit to Okinawa earlier in the year.

8. *Wazome egatari* (The Illustrated Story of Japanese Dyeing)

September 1936, stenciled and hand-painted paper
Closed book: 7⅝ × 6 in. (19.5 × 15.2 cm)
Tōhoku Fukushi University
Serizawa Keisuke Art and Craft Museum

Undertaken as a form of relaxation from his arduous work on *Ehon Don Kihōte* (see cat. 9), *Wazome egatari* was the first book Serizawa produced (in a limited private edition of 115 copies) using the combination of stenciling and hand painting that he had adopted on the advice of Yanagi Muneyoshi.

9. *Ehon Don Kihōte*
(A Don Quixote Picture Book)

Title page dated October 1936 but book completed
1937, paper stenciling and hand painting on paper
Closed book: 11¼ × 8¼ in. (28.7 × 20.8 cm)
Tōhoku Fukushi University
Serizawa Keisuke Art and Craft Museum

Ehon Don Kihōte was Serizawa's first foreign
commission, created at the request of the Boston
accountant Carl Keller. Serizawa selected more
than thirty scenes from Cervantes's novel and
re-imagined Don Quixote as a samurai, replacing
the famous windmills with waterwheels and
Catholic priests with Buddhist priests. The color
scheme and compositional approach evoke
Japanese printed books of the early seventeenth
century, which often depicted tales from the
samurai past. For a detailed discussion of this
work, see the essay by Matthew Fraleigh in this
catalogue.

10. Book Cover
Van Hohho no shōgai to seishinbyō
(Van Gogh's Life and Mental Illness)
by Shikiba Ryūzaburō

1932, stencil-dyed cotton
11⅜ × 8⅝ in. (29 × 22 cm)
Tōhoku Fukushi University
Serizawa Keisuke Art and Craft Museum

Serizawa's work for *Kōgei* magazine (see cat. 11) earned him a reputation as a designer of book covers, and he soon began to receive commissions from Shikiba Ryūzaburō, a multifaceted individual who not only ran a mental facility in Serizawa's hometown of Shizuoka but also published widely on Western art and sexology, translated works by the marquis de Sade, and, beginning in 1939, edited the monthly magazine *Gekkan mingei*. This was Serizawa's first book (rather than magazine) cover design, and the entire project, including the wrapper, slipcase, endpapers, title page, contents page, and other elements, took a year to complete. It was exhibited at the seventh Kokugakai exhibition in 1932. After this success, Serizawa's services as a book designer were in high demand, at first from members of Yanagi Muneyoshi's immediate circle and later from such celebrated authors as Kawabata Yasunari.

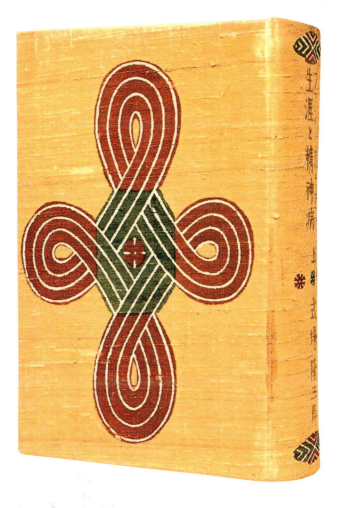

11. Magazine Covers
Kōgei (Craft) Magazine, Issues 11 and 65

1931 and 1936, stencil-dyed cotton
Each 8⅞ × 6⅛ in. (22.6 × 15.7 cm)
Tōhoku Fukushi University
Serizawa Keisuke Art and Craft Museum

In 1930 Yanagi Muneyoshi asked Serizawa to design covers for *Kōgei* magazine, the ambitious publishing project that would bring Yanagi's ideas about mingei to a wider public. Originally based on characters in Yanagi's own calligraphy, for the first twelve issues the design was changed every three months; Serizawa also designed covers for issues 61 through 72, as well as a few others. The *Kōgei* commission not only made Serizawa's design talent known to a larger audience, it also gave him valuable experience in the production techniques required to produce some five hundred to six hundred copies of the same design each month to a strict deadline.

13. Cover: *Ainu Geijutsu* (Ainu Arts), **Numbers 1–3, by Kindaichi Kyōsuke and Sugiyama Sueo**

September 1941–January 1943, stencil-dyed hemp
11⅞ × 8⅜ in. (30.3 × 21.4 cm)
Serizawa Keiko Collection

12. Wrapper: *Kōgei* (Craft) **Magazine**

c. 1932, stencil-dyed cotton
9 × 6¾ × 4¾ in. (23 × 17 × 12 cm)
Tōhoku Fukushi University
Serizawa Keisuke Art and Craft Museum

Starting in 1932, Yanagi commissioned Serizawa to design wrappers to hold a whole year's issues of *Kōgei* magazine; in all, he designed ten such wrappers. Serizawa exhibited the 1932 wrapper alongside other new works at the Kokugakai exhibition, thereby earning full membership in the organization, which he left in 1937 following a quarrel between Yanagi Muneyoshi and the potter Tomimoto Kenkichi.

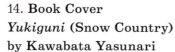

14. Book Cover
Yukiguni (Snow Country)
by Kawabata Yasunari

June 1937, stencil-dyed paper
7½ × 5⅓ in. (19.2 × 13.5 cm)
Tōhoku Fukushi University
Serizawa Keisuke Art and Craft Museum

This subdued binding reflects traditional Edo-period (1615–1868) book-cover design, perhaps in reaction to the understated, allusive style of Kawabata's celebrated novel. Kawabata presented different parts of the novel in several different journals before bringing them together in this single volume in 1937; he then rewrote the text several times before it reached its final form in 1948.

15. Book Cover
Rōtorekku: Shōgai to Geijutsu
(Lautrec: Art and Life)
by Shikiba Ryūzaburō

July 1942, stencil-dyed hemp
10⅝ × 7⅞ in. (27 × 20 cm)
Tōhoku Fukushi University
Serizawa Keisuke Art and Craft Museum

For Shikiba Ryūzaburō, see catalogue 10.

16. Title Sheet, February, June, and October, from a Calendar for 1946

1945, stencil-dyed paper
Each 14⅝ × 10⅞ in. (37.2 × 27.6 cm)
Yunoki Samiro

In 1943, Serizawa published his first book in which both the black outlines and the colored areas were applied through stencils, creating a much richer effect than he had achieved previously with a combination of stenciling and hand painting. Two years later, at the conclusion of World War II, his patron Shikiba Ryūzaburō (see also cats. 10, 15) persuaded him to design the first of his paper calendars, which feature a rich medley of motifs drawn not only from traditional Japanese and Okinawan design but also from Western traditions of manuscript decoration. The original plan was to

print the designs using conventional technology, but because Serizawa could not meet the printers' deadline he produced the calendars using stencils and was so pleased with the result that he decided to continue making them the same way. At the peak of the calendars' popularity, the Serizawa Paper-Dyeing Research Institute, founded in 1955, was publishing more than ten thousand copies a year, all of them hand stenciled. The designs became even more widely known through the miniature conventionally printed version that is still widely sold every fall.

17. Bamboo Grass and Peonies

1935, obi length, stencil-dyed tsumugi-weave silk
w.: 14 in. (35.5 cm)
Shizuoka City Serizawa Keisuke Art Museum

In this early example of silk stencil dyeing, dating
from several years before Serizawa's first visit
to Okinawa in 1939, the artist is already beginning
to emulate the somewhat uneven white outlines
that are seen in Okinawan textiles when rice-
paste resist is applied to designs before the ground
color is dyed.

18. Knots

c. 1936, obi length, stencil-dyed hemp
w.: 13½ in. (34.2 cm)
Tōhoku Fukushi University
Serizawa Keisuke Art and Craft Museum

19. Tantric Twisted Rope

1947, wall hanging, stencil-dyed yamamayu silk
50 × 40⅛ in. (127 × 102 cm)
Serizawa Keiko Collection

As postwar shortages gradually eased, Serizawa was able to return to working with fabric as well as paper, his principal medium during the early 1940s. In this and the following examples, he deployed his technical mastery to create complex interlaced patterns that demanded the ability to cut, and apply resist through, extremely fine openings in the stencil.

20. Knots

1946, wall hanging, stencil-dyed hemp
46¼ × 14⅜ in. (117.5 × 36.5 cm)
Tōhoku Fukushi University
Serizawa Keisuke Art and Craft Museum

For a later development of this design idea, see catalogue 43, where the knots take the form of the Chinese character *kotobuki* (long life).

21. Tantric Twisted Rope

1946, tablecloth, stencil-dyed yamamayu silk
56 × 22¾ in. (142.2 × 57.7 cm)
Serizawa Keiko Collection

22. Geometric Designs

1940s, wall hanging, stencil-dyed yamamayu silk
69 × 24¼ in. (175.3 × 61.7 cm)
Serizawa Keiko Collection

23. Portrait of Hōnen Shōnin

1942, hanging scroll, stencil-dyed silk
Overall size: 86¼ × 31¾ in. (219 × 80.7 cm)
Tōhoku Fukushi University
Serizawa Keisuke Art and Craft Museum

First executed in 1938, this powerful stenciled portrait of Saint Hōnen (1133–1212), founder of the Pure Land sect, is among Serizawa's most celebrated figural works. Much smaller versions of the same image, executed in a combination of black stenciled lines and hand coloring, appear more than once in a picture book by Serizawa on Hōnen's life, *Hōnen Shōnin eden* (The Illustrated Life of Saint Hōnen), that was commissioned in late 1938 and completed in 1941. Himself a follower of Pure Land Buddhism, Serizawa is said to have had the earlier large-scale portrait hanging in his workshop while he worked on the book. Hōnen is shown reciting the *nenbutsu* (a repeated invocation of the Buddha's name) with the help of a rosary, his pose and expression powerfully evoking both religious humility and doctrinal conviction.

24. Christ

1944, stencil-dyed paper
Overall size: 36⅞ × 20⅜ in. (93.7 × 51.7 cm)
Tōhoku Fukushi University
Serizawa Keisuke Art and Craft Museum

Although he was not a Christian, Serizawa
was eclectic in his choice of religious subject
matter and often created icons of Jesus Christ
as well as Buddhist deities and saints. While
the style of this image clearly reflects medi-
eval European influences, the color scheme is
similar to that of the portrait of the Bodhisat-
tva Jizō (see cat. 99).

25. Papermaking Village in Ogawa

1941, hanging scroll, stencil-dyed cotton
Overall size: 50 × 33¾ in. (127 × 85.7 cm)
Japan Folk Crafts Museum

In contrast to the detailed, consistent, repeated pattern seen in the slightly later kimono (see cat. 6), this bolder version of the Ogawa theme incorporates not just houses and drying boards for the finished sheets of paper but also a distant peak that is depicted in the tripartite form first seen in medieval pilgrimage mandalas. In the same way that the mandalas feature bands of cloud to emphasize the mountain's lofty sacred aspect, Serizawa's composition, its strict symmetry dictated by the use of both sides of the stencil, includes a stylized river and a large area of undyed cotton.

26. The Great Market in Naha City, Okinawa

1940, hanging scroll, stencil-dyed paper
61¼ × 27¾ in. (155.5 × 70.5 cm)
Tōhoku Fukushi University
Serizawa Keisuke Art and Craft Museum

In 1928, Serizawa's first encounter with Okinawan bingata textiles inspired him to devote his life to the art of stencil dyeing, but it was not until late 1939 that he fulfilled his wish to visit the islands of Okinawa, as a member of a large group led by Yanagi Muneyoshi (who had first gone there in 1933). Serizawa spent two months studying the bingata process and began collecting Okinawan folk crafts (starting with textiles), sketching scenes from everyday life, and enjoying Okinawan theater and popular songs. The islands were not just the source of a new technique but also a cultural inspiration. Serizawa would later write that Okinawa was his "Dragon Palace," a reference to the fabled submarine paradise of the king of the sea.

27. Paper Dolls and Everyday Objects

Stencil first cut in 1949, hanging scroll, stencil-dyed paper
Overall size: 81⅜ × 24⅞ in. (206.8 × 63.2 cm)
Tōhoku Fukushi University
Serizawa Keisuke Art and Craft Museum

The upper part of this design shows paper dolls
from Kagoshima in southern Japan, *hishimochi*
(diamond-shaped rice cakes), flowers, and lacquer
pouring bowls and food boxes. The lower part
includes a *tansu* (chest), books, an inkstone box,
kitchen knives, a vegetable basket, combs and
hair decorations, a porcelain jar with a peony and
scissors, a *hagoita* (decorative racket; see also
cat. 5), a shuttlecock and ball, a thread winder
and cloth, and a kitchen oven.

28. Pine Tree

1955, noren (entrance curtain), stencil-dyed hemp
48⅜ × 27¾ in. (123 × 70.5 cm)
Tōhoku Fukushi University
Serizawa Keisuke Art and Craft Museum

29. Nawa Noren (Straw Rope Curtain)

1955, noren (entrance curtain), stencil-dyed cotton
47½ × 34⅞ in. (120.5 × 88.5 cm)
Tōhoku Fukushi University
Serizawa Keisuke Art and Craft Museum

This clever self-referential design (a curtain on a curtain), much in demand even today in low-cost, mass-produced versions, exemplifies Serizawa's unique fusion of a modernist aesthetic with a traditional attitude toward the inherent value of craft processes and materials.

30. "Kono yamamichi o yukishi hito ari" (Another Trod This Mountain Path Before), Two Lines from a Poem by Origuchi Shinobu

1959, noren (entrance curtain), stencil-dyed cotton
49½ × 29¾ in. (125.6 × 75.5 cm)
Tōhoku Fukushi University
Serizawa Keisuke Art and Craft Museum

This famous line is from a verse by the poet and folklorist Origuchi Shinobu (1887–1953). It was composed in 1924 when Origuchi was researching rural traditions on the island of Oki. The poem reads in full: "Kuzu no hana / fumishidakarete / iro atarashi / kono yamamichi o / yukishi hito ari" (The arrowroot flowers / lie crushed and broken, their bright / colors stain the ground / telling me that another / trod this mountain path before).

31. Morning Glories

1963, noren (entrance curtain), stencil-dyed hemp
51⅛ × 29 in. (130 × 73.6 cm)
Tōhoku Fukushi University
Serizawa Keisuke Art and Craft Museum

32. Dyeing Board with Cloth, Brush, and Spatula

1960, noren (entrance curtain), stencil-dyed cotton
49⅝ × 28⅜ in. (126 × 72 cm)
Tōhoku Fukushi University
Serizawa Keisuke Art and Craft Museum

Here Serizawa depicts the tools of his own trade in graphically simplified form. For an account of the kataezome dyeing process, see "The Kata-ezome Technique" in this catalogue.

33. Nachi Waterfall

1962, noren (entrance curtain), stencil-dyed
tsumugi-weave silk
52⅛ × 39⅛ in. (132.4 × 99.4 cm)
Tōhoku Fukushi University
Serizawa Keisuke Art and Craft Museum

Located in Wakayama Prefecture, the Nachi waterfall,
with its drop of more than four hundred feet, has been
a celebrated natural wonder since early times and is
depicted in a famous late-thirteenth-century Shinto
painting. Although he sketched the actual waterfall two
years before executing this piece, Serizawa was clearly
influenced by the spare, almost abstract design of the
painting, which he emulated using varying intensities
of indigo dye against a white background.

34. Chinese Character *Hito* (Man) and Pine Trees

1964, hanging scroll, stencil-dyed silk
Overall size: 65 × 19⅝ in. (165.1 × 49.7 cm)
Serizawa Keiko Collection

35. Chinese Characters
Haru (Spring), *Natsu* (Summer), *Aki* (Fall), and *Fuyu* (Winter)

1965, pair of hanging scrolls, stencil-dyed paper
Overall size of each: 80¼ × 27⅜ in. (203.7 × 69.5 cm)
Tōhoku Fukushi University
Serizawa Keisuke Art and Craft Museum

The characters are arranged from top to bottom and right to left. For a discussion of Serizawa's use of Chinese characters, see catalogue 49 and the essay by Terry Satsuki Milhaupt in this catalogue.

36. Bamboo Grass

1973, noren (entrance curtain), stencil-dyed
madanuno (cloth woven from the bark of the
Japanese linden tree)
59¾ × 43¼ in. (151.8 × 110 cm)
Tōhoku Fukushi University
Serizawa Keisuke Art and Craft Museum

37. Chinese Character *Yama* (Mountain)

1968, noren (entrance curtain), stencil-dyed madanuno
(cloth woven from the bark of the Japanese linden tree)
52 × 28⅜ in. (132 × 72 cm)
Tōhoku Fukushi University
Serizawa Keisuke Art and Craft Museum

38. Chinese Character *Wa* (Harmony)

1935 or possibly c. 1955, stencil-dyed
tsumugi-weave silk
39⅛ × 29⅜ in. (99.5 × 74.5 cm)
Tōhoku Fukushi University
Serizawa Keisuke Art and Craft Museum

This and the following design are dated 1935 in
Serizawa Keisuke zenshū, a thirty-one-volume
authorized compendium of Serizawa's oeuvre
completed in 1983, but it has been argued that
they may have been done around 1955, when
he was starting to experiment with Chinese-
character motifs.

39. Chinese Character *Fuku* (Good Fortune)

1935 or possibly c. 1955, stencil-dyed tsumugi-weave silk
35⅜ × 32⅛ in. (90 × 81.5 cm)
Tōhoku Fukushi University
Serizawa Keisuke Art and Craft Museum

40. Chinese Character *Kotobuki* (Long Life)

1974, noren (entrance curtain), stencil-dyed cotton
61⅝ × 43⅝ in. (156.6 × 110.8 cm)
Tōhoku Fukushi University
Serizawa Keisuke Art and Craft Museum

41. Chinese Character _Hana_ (Flower)

1960, noren (entrance curtain), stencil-dyed cotton

47⅝ × 29½ in. (121 × 75 cm)

Tōhoku Fukushi University

Serizawa Keisuke Art and Craft Museum

42. Bamboo and Peony in the Chinese Character _Fuku_ (Good Fortune)

1955, noren (entrance curtain), stencil-dyed cotton

61⅛ × 31¾ in. (155.4 × 80.5 cm)

Tōhoku Fukushi University

Serizawa Keisuke Art and Craft Museum

43. Knots in the Form of the Chinese Character *Kotobuki* (Long Life)

1960, noren (entrance curtain), stencil-dyed cotton
56⅛ × 32¼ in. (142.7 × 82 cm)
Tōhoku Fukushi University
Serizawa Keisuke Art and Craft Museum

44. Chinese Character *Kaze* (Wind)

1957, noren (entrance curtain), stencil-dyed cotton
37⅝ × 26⅝ in. (95.5 × 67.5 cm)
Tōhoku Fukushi University
Serizawa Keisuke Art and Craft Museum

45. Chinese Character *Hana* (Flower)

1960s, stencil-dyed tsumugi-weave silk
37¼ × 19¼ in. (94.5 × 48.8 cm)
Tōhoku Fukushi University
Serizawa Keisuke Art and Craft Museum

 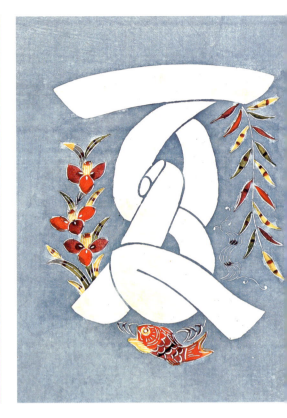

46. Chinese Character
Fuyu **(Winter)**

1954, stencil-dyed paper
29⅞ × 24½ in. (76 × 62.2 cm)
Tōhoku Fukushi University
Serizawa Keisuke Art and Craft Museum

47. Chinese Character
Aki **(Fall)**

1954, stencil-dyed paper
29⅞ × 24½ in. (76 × 62.2 cm)
Tōhoku Fukushi University
Serizawa Keisuke Art and Craft Museum

48. Chinese Character
Natsu **(Summer)**

1954, stencil-dyed paper
29⅞ × 24½ in. (76 × 62.2 cm)
Tōhoku Fukushi University
Serizawa Keisuke Art and Craft Museum

49. Chinese Character
Haru (Spring)

1954, stencil-dyed paper
29⅞ × 24½ in. (76 × 62.2 cm)
Tōhoku Fukushi University
Serizawa Keisuke Art and Craft Museum

Serizawa's interest in the decorative potential of Chinese characters may have first been inspired by his grandfather, a distinguished calligrapher, and was encouraged by Yanagi Muneyoshi's commissions to design covers for *Kōgei* magazine (see cat. 11). However, as Terry Satsuki Milhaupt points out in her essay in this catalogue, the combination of character and motif seen in this and the previous three designs (cats. 46–48) also shows close affinities to the type of Korean folk painting that Serizawa started to acquire in 1953 after much of his original collection was destroyed in the firebombing of Tokyo.

50. Chinese Character *Shin* (Faith)

1960, stencil-dyed tsumugi-weave silk
Overall size: 37¼ × 19¼ in. (94.5 × 49 cm)
Tōhoku Fukushi University
Serizawa Keisuke Art and Craft Museum

51. Chinese Character *Shin* (Truth)

1960, stencil-dyed hemp
Overall size: 37¼ × 19¼ in. (94.5 × 49 cm)
Tōhoku Fukushi University
Serizawa Keisuke Art and Craft Museum

52. Chinese Characters and Motifs of the Four Seasons

1954, four-leaf screen, stencil-dyed hemp
39⅝ × 68½ in. (100.5 × 174 cm)
Serizawa Keiko Collection

Read from right to left in the traditional East Asian manner, the
characters are *haru* (spring), *natsu* (summer), *aki* (fall), and *fuyu* (winter).

53. Bandori (Padded Carrying Harness)

1957, four-leaf screen, stencil-dyed tsumugi-weave silk
Overall size: 61⅜ × 97⅝ in. (156 × 248 cm)
Tōhoku Fukushi University
Serizawa Keisuke Art and Craft Museum

Bandori, pads made from woven straw and
textile, are typical products of the Tohoku
(northeastern Honshu) region, which Serizawa
had visited several times in the 1930s and 1940s.

54. Mandala of the Four Seasons

1971, two-leaf screen, stencil-dyed tsumugi-weave silk
Overall size: 70¼ × 70⅜ in. (178.2 × 178.8 cm)
Tōhoku Fukushi University
Serizawa Keisuke Art and Craft Museum

Originally designed as a tribute to the late
President Kennedy, this ambitious composition
emulates a medieval esoteric rendering of the
Buddhist cosmos, its spatial and temporal param-
eters indicated here by characters for the four
cardinal points (in the corners) and the four sea-
sons (between the nested squares in the central
section). The other motifs, ranging from a selec-
tion of the *takaramono* (auspicious objects such
as the clove and the hat and cloak of invisibility)
to plants, insects, and squares evoking Korean
lacquer decoration, are an extraordinary amal-
gam of Serizawa's many and varied inspirations.

55. Japanese Syllables

1958, six-leaf screen, stencil-dyed paper
66⅞ × 103⅛ in. (170 × 262 cm)
Serizawa Keiko Collection

For an earlier screen featuring the forty-seven
symbols of the Japanese hiragana syllabary,
see catalogue 5. In this looser treatment,
with the cursive graphs intermingling freely
with images, Serizawa selected a different list
of objects whose names start with the same
syllable. The objects on the far-right panel are
igasa (rush hat), *rokuro* (potter's wheel), *bashō*
(banana leaf), *niwatori* (chicken), *botan* (peony),
hei (wall), *tō* (pagoda), and *chawan* (teabowl).

56. Papermaking Village in Ogawa

c. 1960, six-leaf screen, stencil-dyed paper
25¼ × 83½ in. (64 × 212.2 cm)
Tōhoku Fukushi University
Serizawa Keisuke Art and Craft Museum

For the papermaking village of Ogawa, see
catalogues 6 and 25. In this narrative sequence
Serizawa details the various stages of tradi-
tional paper manufacture. From right to left:
boiling branches of paper mulberry in a large vat
mounted on a stove; washing the boiled fibers
in running water; softening the fibers by beating
them with mallets and paddles; molding the
paper in a frame; removing excess water in a
press; and drying the finished sheets of paper in
the sun. A much earlier version of this subject,
done in the late 1930s when Serizawa was still
working in Ogawa, is in the Victoria and Albert
Museum, London.

**57. Chinese Characters *Ame* (Rain) and
Hare (Sunshine) with Summer Plants**

1962, two-leaf screen, stencil-dyed paper
Overall size: 21 × 74⅛ in. (53.2 × 188.4 cm)
Tōhoku Fukushi University
Serizawa Keisuke Art and Craft Museum

**58. Chinese Characters for the
Four Seasons**

1970, four-leaf screen, stencil-dyed
tsumugi-weave silk
67⅜ × 105 in. (171 × 266.8 cm)
Tōhoku Fukushi University
Serizawa Keisuke Art and Craft Museum

Read from right to left in the traditional
East Asian manner, the characters are
haru (spring), *natsu* (summer), *aki* (fall),
and *fuyu* (winter).

59. Japanese Books and Scrolls

1968, two-leaf screen, stencil-dyed tsumugi-weave silk
27⅜ × 72⅞ in. (69.5 × 185 cm)
Tōhoku Fukushi University
Serizawa Keisuke Art and Craft Museum

Although the objects depicted here are Japanese, the style
of this screen was probably inspired by Korean examples
of the eighteenth and nineteenth centuries that feature books
and other furnishings of a scholar's studio. The volumes
shown at right include a late-seventeenth-century or early-
eighteenth-century *hinagata-bon* (kimono design album)
and a guide to the *mon* (family crests) that inspired many
of Serizawa's circular motifs.

60. Japanese Syllables

1973, two-leaf screen,
stencil-dyed tsumugi-weave silk
Overall size: 68 × 73½ in. (172.7 × 186.6 cm)
Shizuoka City Serizawa Keisuke
Art Museum

In contrast to the two other screens in this catalogue featuring the forty-seven symbols of the hiragana syllabary (cats. 5, 55), this example does not also show images of objects whose names begin with the same syllable. This approach favors the sparser, more graphic style that Serizawa generally preferred during the 1960s and 1970s.

61. Scenes in Okinawa

1954, kimono, stencil-dyed cotton
61⅜ × 51 in. (156 × 129.5 cm)
Tōhoku Fukushi University
Serizawa Keisuke Art and Craft Museum

For Serizawa's travels to Okinawa, see catalogue 26 and the essay by Amanda Mayer Stinchecum in this catalogue.

62. Fallen Leaves

1953, kimono, stencil-dyed crepe silk
65 × 55¼ in. (165 × 140.2 cm)
Tōhoku Fukushi University
Serizawa Keisuke Art and Craft Museum

63. Small Flowers in Fingernail Shapes

1952, kimono, stencil-dyed crepe silk
61 × 50⅜ in. (155 × 127.8 cm)
Itō Miyako

64. Fishing Boats

1958, kimono, stencil-dyed silk gauze
64¾ × 49⅝ in. (164.5 × 126 cm)
Tōhoku Fukushi University
Serizawa Keisuke Art and Craft Museum

The maritime subject matter and bold
repeat design are typical of Serizawa's
Tsumura period (see cat. 69).

**65. Pattern Imitating
Glaze Dripping Down
the Side of a Jar**

1961, kimono, stencil-dyed
banana-bark cloth
61 × 50 in. (155 × 127 cm)
Tōhoku Fukushi University
Serizawa Keisuke Art and Craft Museum

66. Pine, Plum, and Snow-Laden Grasses

1960, kimono, stencil-dyed crepe silk
66⅛ × 52 in. (168 × 132 cm)
Shizuoka City Serizawa Keisuke
Art Museum

67. Seashells

1963, kimono, stencil-dyed silk gauze
62¾ × 51⅛ in. (159.5 × 130 cm)
Shizuoka City Serizawa Keisuke
Art Museum

For the background to this bold
maritime design, see catalogue 69.

68. Banana Leaves

1964, kimono, stencil-dyed
banana-bark cloth
57⅜ × 52 in. (145.8 × 132.1 cm)
Tōhoku Fukushi University
Serizawa Keisuke Art and Craft Museum

69. Seabream

1964, kimono, stencil-dyed tsumugi-weave silk
62¼ × 51⅛ in. (158 × 130 cm)
Tōhoku Fukushi University
Serizawa Keisuke Art and Craft Museum

This striking symmetrical composition, which exploits to the full both the reversibility of the stencils and the simple tailoring of a traditional kimono, is one of best-known works of Serizawa's Tsumura period. Following his official appointment in 1956 as Holder of an Important Intangible Cultural Property, or Living National Treasure, Serizawa encountered a problem that has beset many subsequent honorees: it was difficult to find the time for creative thinking. In 1957 he rented a simple farm building in Tsumura, near Kamakura, an hour or two by train from Tokyo, converted it into a studio, and spent much of his time there for more than ten years. Not only was he free from the distractions of celebrity, the area was rich in ready-made design motifs. When he was not busy turning out illustrations for the *Asahi Shimbun* newspaper (see cats. 87, 89), just a few steps away from his studio he could find subjects for some of his finest textile designs, and this kimono had its origin in sketches made on the Kamakura seashore. The design excited the attention of the Polish-French painter Balthus (Balthasar Klossowski de Rola, 1908–2001) when he visited Serizawa in 1965. On his return to France, Balthus was instrumental in laying plans for the Serizawa exhibition that was eventually held at the Grand Palais, Paris, in 1976.

70. Trees

c. 1962, kimono, stencil-dyed
tsumugi-weave silk
59½ × 48 in. (151 × 122 cm)
John C. Weber Collection

71. Mountains of Tsumura

1967, kimono, stencil-dyed crepe silk
66½ × 50¾ in. (169 × 129 cm)
Shizuoka City Serizawa Keisuke
Art Museum

For Tsumura, the rural retreat
Serizawa began renting in 1957,
see catalogue 69.

72. Abstract Designs

1976, kimono, hand-painted and
stencil-dyed tsumugi-weave silk
64⅛ × 51⅜ in. (163 × 130.4 cm)
Kashiwa City

73. Willow

1960, wall hanging, stencil-dyed hemp
61 × 78 in. (155 × 198 cm)
Shizuoka City Serizawa Keisuke
Art Museum

74. Scenes in Okinawa

1954, obi length, stencil-dyed crepe silk
W.: 14⅛ in. (36 cm)
Tōhoku Fukushi University
Serizawa Keisuke Art and Craft Museum

For Serizawa's travels to Okinawa, see catalogue 26 and the essay by Amanda Mayer Stinchecum in this catalogue.

75. **Japanese Syllables**

1960s, stencil-dyed raw silk
25¾ × 13¾ in. (65.5 × 35 cm)
John C. Weber Collection

76. Suns

1955, obi length, stencil-dyed cotton
w.: 13⅞ in. (35.2 cm)
Kashiwa City

77. Zigzags

1955, obi length, stencil-dyed crepe silk
w.: 14 in. (35.5 cm)
Tōhoku Fukushi University
Serizawa Keisuke Art and Craft Museum

78. Small Flowers

c. 1960, obi length, stencil-dyed tsumugi-weave silk
w.: 14 in. (35.5 cm)
Tōhoku Fukushi University
Serizawa Keisuke Art and Craft Museum

77.

78.

79. Korean Boxes

1965, stencil-dyed tsumugi-weave silk
28¾ × 18 in. (73 × 45.7 cm)
Tōhoku Fukushi University
Serizawa Keisuke Art and Craft Museum

In 1914 a Korean ceramic jar first awakened
Yanagi Muneyoshi, founder of the mingei
movement, to the beauty of everyday crafts,
and Korean artifacts would play an important
part in the development of the movement.
Serizawa, who first visited Korea in 1927, was
especially drawn to the country's shell-inlaid
lacquer wares. In keeping with mingei aesthetic
preferences, here he depicts not refined, courtly
lacquers made for Buddhist liturgical use in
the twelfth century but plainer, boldly decorated
wares that became popular in the seventeenth
century. Such wares strongly influenced the
work of Kuroda Tatsuaki (1904–1982), the min-
gei movement's leading lacquer artist.

80. Thatched Huts in Tsumura

1967, obi length, stencil-dyed crepe silk
w.: 14⅛ in. (36 cm)
Tōhoku Fukushi University
Serizawa Keisuke Art and Craft Museum

For Tsumura, the rural retreat Serizawa first
rented in 1957, see catalogue 69.

81. Doll Holding a Seabream

1969, stencil-dyed paper
25¾ × 21⅝ in. (65.3 × 55 cm)
Tōhoku Fukushi University
Serizawa Keisuke Art and Craft Museum

82. Bamboo and Plum Blossoms

1970, obi length, stencil-dyed tsumugi-weave silk
w.: 14⅛ in. (36 cm)
Shizuoka City Serizawa Keisuke Art Museum

83. Book Cover: *Shūshū Monogatari* (A Collector's Tales), by Yanagi Muneyoshi

1956, stencil-dyed paper
8⅞ × 6⅛ in. (22.5 × 15.5 cm)
Tōhoku Fukushi University
Serizawa Keisuke Art and Craft Museum

84. *Butsuge* or *Mono-uta* (In Praise of Things), Quotations from Yanagi Muneyoshi and Other Members of the Mingei Movement, Fifth Collection

Fall 1957, stencil-dyed paper
Each 10¼ × 8¼ in. (26 × 21 cm)
Tōhoku Fukushi University
Serizawa Keisuke Art and Craft Museum

85. *Hariko Iroiro* (Papier-Mâché Toys)

January 1961, hand painting on paper
Closed book: 14¼ × 11⅜ in. (36 × 29 cm)
Serizawa Keiko Collection

86. Book Cover
Hazekura, by Kon Tōkō

April 1961, stencil-dyed paper
7⅞ × 5⅞ in. (20 × 15 cm)
Tōhoku Fukushi University
Serizawa Keisuke Art and Craft Museum

Hazekura is one of several works of historical
fiction by Kon Tōkō (1898–1977), a Buddhist
priest, onetime painter, art historian, politi-
cian, and confidant of leading literary figures,
including Tanizaki Jun'ichirō and Kawabata
Yasunari. The novel tells the story of Hasekura
Tsunenaga (1571–1622), a retainer of the war-
lord Date Masamune, who sailed across the
Pacific and Atlantic Oceans at the head of a
diplomatic mission to New Spain and Europe.

87. *Gokuraku Kara Kita Sashie-Shū* (A Collection of Illustrations for *He Came from Paradise*), by Satō Haruo

1961, stencil dyeing and hand painting on paper
Closed book: 13⅛ × 11 in. (33.2 × 28 cm)
Serizawa Keiko Collection

Serizawa designed and executed 173 illustra-
tions for a serialized biography of Hōnen (see cat.
23) by the prolific poet and novelist Satō Haruo
(1892–1964) between March and December 1960,
one of two such projects that he undertook for
the *Asahi Shimbun* newspaper during his Tsumura
period (see cat. 69); the other was the *Shisanmei*
series (see cat. 89). Many readers of the news-
paper found Serizawa's pictures more congenial
than Satō's abstruse text, and the project made
him a national celebrity. On completion of the
serialized version, Serizawa produced this deluxe
edition in 150 copies with hand-painted details.

極楽世界楼閣荘光木図

極楽談義

88. *Kataebon Gobusaku* (Five Books of Stencil Designs)

1964–66, stencil-dyed paper
Closed book: 6¾ × 9 in. (17 × 23 cm)
Tōhoku Fukushi University
Serizawa Keisuke Art and Craft Museum

89. Book Cover: *Shisanmei* (The Tale of a Chinese Woman Ninja), by Takeda Taijun

May 1966, stencil-dyed paper
7½ × 5½ in. (19 × 14 cm)
Tōhoku Fukushi University
Serizawa Keisuke Art and Craft Museum

This novel by Takeda Taijun (1912–1976) was originally serialized in the *Asahi Shimbun* newspaper, with 145 illustrations by Serizawa (see also cat. 90). When it came out in book form, Serizawa designed the cover, selecting the motif of butterfly and peony to match the novel's Chinese theme. Set in the eighteenth century, the novel concerns a beautiful young girl whose parents are murdered. Determined to seek revenge, she apprentices herself to a martial arts expert who teaches her kung fu and gives her the name Shisanmei (Thirteenth Daughter).

90. *Chūgoku Ninjaden Shisanmei Sashie Shū* (A Collection of Illustrations for *The Tale of a Chinese Woman Ninja*)

1968, stencil dyeing and hand painting on paper
Page: 10¾ × 11½ in. (27.4 × 29.4 cm)
Tōhoku Fukushi University
Serizawa Keisuke Art and Craft Museum

Following the publication of the Shisanmei story (see cat. 89) in book form, Serizawa republished his 145 dramatic illustrations to the original serialized version.

89.

90.

91. Illustrations from *Sekai no Mingei Omocha Ningyō* (People's Crafts Toys from Around the World)

1969, hand painting on paper
Each page: 12 × 8⅜ in. (30.4 × 21.4 cm)
Serizawa Keiko Collection

Serizawa's own extensive folk-craft collection, which is still preserved at the Serizawa Keisuke Art and Craft Museum, includes a number of dolls.

92. *Iroiro Shinagaki Tsutsumukami*
(Menus and Covers)

c. 1970, stencil-dyed paper
Closed book: 15½ × 12 in. (39.5 × 30.5 cm)
Serizawa Keiko Collection

93. *Kozara moyō hinagata*
(Designs for Plates)

January 1971, stencil-dyed paper
11⅜ × 10¼ in. (29 × 26 cm)
Tōhoku Fukushi University
Serizawa Keisuke Art and Craft Museum

During his 1939 visit to Okinawa (see cat. 26), Serizawa was much taken by the local ceramics with their predominantly red enamel decoration (*aka-e*). He subsequently built a kiln next to his studio in Kamata, Tokyo, and had the famous mingei potters Hamada Shōji and Tomimoto Kenkichi teach him glazing and firing techniques. Although the kiln was destroyed during the war, Serizawa continued to be interested in ceramic decoration throughout his career.

95. *Katazome Uchiwae Chō*
(An Album of Stenciled Fan Designs)

January 1971, stencil-dyed paper
Page: 13¾ × 15 in. (35 × 38 cm)
Tōhoku Fukushi University
Serizawa Keisuke Art and Craft Museum

94. *Sange* **(Paper Lotus Flowers
Offered to the Buddha)**

c. 1974, stencil-dyed paper
Page: 10¾ × 9½ in. (27.3 × 24.2 cm)
Serizawa Keiko Collection

In 1974, Serizawa designed a set of three scrolls, the
two largest of them eleven feet tall, for the Chion'in,
a Pure Land Buddhist temple in Kyoto, to mark the
sect's eight hundredth anniversary (see cats. 23, 96).
He also made paper flowers (*sange*) for the scrolls'
dedication ceremony, and these were collected by his
son, Chōsuke, and mounted in this album.

妙好人源左

96. *Myōkōnin Inaba no Genza* (Saint Inaba no Genza)

July 1980, stencil-dyed paper
Page: 15 × 14⅜ in. (38 × 36.5 cm)
Tōhoku Fukushi University
Serizawa Keisuke Art and Craft Museum

This book was commissioned by the Ganshōji temple in Tottori Prefecture to mark the fiftieth anniversary of the death of Inaba no Genza, or Gensa (real name, Ashikaga Kizaburō; 1842–1930), a pious, unschoooled local adherent of the Pure Land Buddhist sect whose life embodied the concept of *tariki* (reliance on divine power). Serizawa took twenty-six of the episodes from Genza's life recounted in an earlier publication by Yanagi Muneyoshi and illustrated them using the kataezome technique. Genza's irrepressible, almost Pollyannaish optimism was embodied in the oft-repeated invocation "Yōkoso, yōkoso" (Welcome, welcome), which he used to address not only other people but also every calamity that befell him; these words appear in the book's frontispiece, on either side of Genza, who is shown seated in the customary *seiza* position holding his rosary.

Yanagi, founder of the mingei movement, had already co-written (with Kinugasa Isshō, head priest of Ganshōji) an account of Genza's life in 1950 and was particularly drawn to him for two reasons. First, Genza spent all his life making traditional Japanese paper, a craft that Yanagi had attached special importance to ever since the 1920s (see cat. 6). More significant, Yanagi's later writings on aesthetics were deeply influenced by Pure Land thinking and especially its tradition of *myōkōnin* (marvelously good folk), humble believers like Genza who put their trust in divine power. Yanagi saw a significant parallel between this form of religious faith and the "unknown craftsperson's" unpretentious attitude toward creativity. Only someone with such an attitude, Yanagi contended, could produce the simple, unaffected artifacts that he deemed worthy of the name mingei.

97. Book: *Kōhidō* (The Way of Coffee), by Shishi Bunroku

October 1963, stencil-dyed paper
Closed book: 7⅞ × 5⅞ in. (20 × 15 cm)
Tōhoku Fukushi University
Serizawa Keisuke Art and Craft Museum

According to the original promotional wraparound, this humorous novel by Shishi Bunroku (1893–1969) "shows the world of TV as it really is . . . and the intimate connection between coffee and television, as described by the acid pen of a literary master." The image on the left is the cover.

98. Portrait of Yanagi Muneyoshi

c. 1962, stencil-dyed and painted paper
Overall size: 33⅞ × 26¾ in. (86.2 × 68 cm)
Tōhoku Fukushi University
Serizawa Keisuke Art and Craft Museum

Yanagi Muneyoshi, founder of the mingei move-
ment and longtime mentor of Serizawa, died in
May 1961, the year before this memorial portrait
was executed. Both here and in a series of other
images discovered after Serizawa's death, Yanagi
is presented with a brooding frontality that
recalls the stenciled Christ (cat. 24), in this case
with the addition of a multicolored nimbus or
halo that expresses the artist's deep veneration
for his master.

99. Portrait of the Bodhisattva Jizō

1980, stencil-dyed paper
Overall size: 32⅜ × 32⅜ in. (82.2 × 82.2 cm)
Tōhoku Fukushi University
Serizawa Keisuke Art and Craft Museum

As befits a merciful deity especially revered as
the protector of children, Jizō is presented in
a friendly, almost informal pose that contrasts
with Serizawa's images of Jesus Christ and
Yanagi Muneyoshi (cats. 24, 98).

100. **Mount Fuji and Japanese Syllables** *I, Ro, Ha*

1984, hanging scrolls, painting on paper
Overall sizes: 53⅞ × 25⅛ in. (137 × 63.7 cm) and
53¾ × 25 in. (136.5 × 63.5 cm)
Serizawa Keiko Collection

In these two scrolls, painted during his final illness, Serizawa revisits two of his favorite themes.

Serizawa Keisuke *An Appreciation*

Hiroshi Mizuo

The craft of decorating everyday fabrics with attractive colors and patterns is among the oldest in human history, second in antiquity only to plaiting or weaving plant stems and vines to make basket-like containers. In the earliest forms of dyeing, the threads used to weave a piece of cloth were precolored to produce a plain ground, a stripe, a check, or an *ikat* (in which the yarns are manipulated during weaving to create a pattern or pictorial design) in the finished fabric. At first, dyeing was done by simply rubbing a small quantity of pigment onto the cloth, but over time different techniques were introduced and refined to the point where they could be used to create gorgeous garments and interior fabrics. In resist dyeing, among the most important of those techniques, the areas that are to be left undyed can be twisted, tied, or painted freehand with starch or wax. These methods are still used today, but it is the stencil-dyeing technique that offers the greatest productive and artistic potential, since it makes it possible to duplicate a design by brushing on the resist material through stencils made of stiffened paper.

There are three basic ways of applying dye using precut forms. In one method, the dye is applied directly onto the cloth through a stencil, as seen in some Southeast Asian and Indian calicoes and chintzes, in Japanese *ban'e* textiles of the Heian period (794–1185), and in *kappazuri* prints of the Edo period (1615–1868). A second approach is to protect areas of the fabric from dye by clamping it tightly between two boards

cut with matching images, as seen in *kyōkechi* textiles preserved in the eighth-century Shōsōin repository. Both these methods have long been in decline and are rarely used today. In the third method, called *katazome*, a resist paste is either brushed or rubbed onto the fabric through a stencil. This technique flourished in several different forms during the Edo period and was used to create many different types of design, including *komon*, a tiny repeated pattern; the medium-scale *chūgata*; *kata-Yūzen*, a stenciled form of

fig. 1 Serizawa Keisuke, *Japanese Syllables,* 1958. Kimono, stencil-dyed tsumugi-weave silk, 64¾ × 50¾ in. (164.5 × 129 cm). Fujimoto Takumi.

fig. 2 Serizawa Keisuke, *House in Shuri, Okinawa,* 1939. Hanging scroll, stencil-dyed hemp, 52⅜ × 22¾ in. (133 × 57.8 cm). Tōhoku Fukushi University Serizawa Keisuke Art and Craft Museum.

the Yūzen style of freehand resist dyeing; and *bingata,* a version of the technique that was used in the Ryukyu Islands (in present-day Okinawa Prefecture).

Serizawa Keisuke used the katazome technique, but when in 1956 he was named Holder of an Important Intangible Cultural Property (popularly known as a Living National Treasure), the Committee for the Preservation of Cultural Properties decided to create a new category specifically for him, which they named *kataezome* (stencil-picture dyeing). This decision probably reflected the fact that Serizawa's work was so much richer in pictorial expression than its historical antecedents: a tightly knit fusion of stencil, picture, and dyeing that was his own unique creative achievement (fig. 1). His first encounter with stencil dyeing came in 1928 at an exhibition held to mark the enthronement of the Emperor Hirohito that included a well-received model home called the Mingeikan (People's Crafts Pavilion), a precursor of the permanent museum of the same name that opened in 1936. The Mingeikan was managed by the Mingei (People's Crafts) Association, a group led by Yanagi Muneyoshi, and it was there that Serizawa was deeply struck, both visually and spiritually, by an example of Okinawan bingata. He had met Yanagi the previous year when the latter visited his home in Shizuoka to view his collection of *ema* (small painted wooden plaques customarily offered at Shinto shrines), and it was also in 1927 that he began to read a series of articles by Yanagi titled "Kōgei no michi" (The Way of the Crafts), an experience that sparked his interest in the world of the crafts. For Serizawa, the Okinawan bingata was like a guiding light that indicated the path his career should take and the type of work he should aspire to. Brought up in the city of Shizuoka, a center of the dyeing industry, and already deeply familiar with this ancient craft tradition, he was naturally drawn to bingata's pure, clean designs and bright colors.

For Serizawa, bingata was an instant source of inspiration, and he lost no time in mastering its tech-

niques and successfully putting his work to the test through the annual public exhibitions of the Koku-gakai, originally an association of painters that added a crafts section in 1927. In addition, Yanagi gave Serizawa an opportunity to develop and internalize his dyeing skills by commissioning him to create textile covers for early issues of *Kōgei* (Craft), a magazine Yanagi founded in 1931 (see cat. 11). Three years later Serizawa moved his home and workshop to Kamata in Tokyo, and this became the base for his wide-ranging and varied creative work. During his Kamata period he produced a series of masterpieces in the kataezome technique, trained many outstanding master dyers, and used the house as a gallery for the display of his large collection of crafts of many countries and periods.

Stenciling is widely regarded as the most authentic dyeing technique, and Serizawa shared this view, since stencils facilitate large-scale production and make it possible to create many copies of a single design, one of the essential differences between craft and art. A sec-

ond reason for Serizawa's advocacy of the stenciling process was the way its various steps helped filter out any tendency toward arbitrariness or undue individuality on the part of its practitioners. This advantage, an essential feature of craft work, is apparent in the tools used in other media—for example, the textile loom or the potter's wheel—but it is especially apparent in stencil dyeing. The two stages of cutting the stencil and applying the dye act like a double filter, forestalling some of the problems inherent in a search for an "individual" creativity, including exaggeration or even pathological distortion; one could almost say that the stencil process distills and deepens the best features of the artist's creativity. The third reason for Serizawa's espousal of stencil dyeing was the way the stenciled motifs themselves seem to seek out colors that are appropriate to the purity of their outlines. A skilled dyer senses from experience when a textile design might be thrown out of balance by an overly rich palette or the use of impure colors, and knows what steps to take to put things right. Serizawa was unusually well endowed with this innate ability to judge the effect of a stenciled design. As we can see from his sketches, design albums, and finished paintings, he had a lively, free-spirited talent for the brush and could have secured an important place in the history of Japanese art had he decided to become a painter, but by choosing stencil dyeing he was able to develop a brilliant yet understated style that was never undisciplined or overelaborate. His shy and conscientious character was ideally suited to the natural restraints inherent in the stencil-dyeing process.

Serizawa made many different types of object from the fabrics and papers he dyed, including lengths of cloth for kimonos, complete kimonos, obis, *noren* (entrance curtains), wallpapers, curtains, tablecloths, screens, *furoshiki* (wrapping cloths used to carry food boxes, gifts, and other items), hanging scrolls, *fusuma* (sliding room dividers), *futon* (quilt covers), folding and nonfolding fans, calendars, posters,

wrapping paper, bookplates, commercial signs, restaurant menus, matchbox covers, book bindings and jackets, illustrated books, large- and small-scale book illustrations, and pictures (fig. 2). The motifs that he used ranged from birds, flowers, and other natural themes through buildings, human figures, and tools to geometric, cursive, and abstract patterns. He also produced a vast number of sketches, preliminary designs, paintings on board, works of stained glass, and decorated ceramics. His personal collection of craft works, another expression of his creativity, was wide ranging in scope and outstanding in both quality and quantity. It included textiles from all over the world, craft productions of every kind, and ethnic masks. His exhibition installations at the Grand Palais, Paris, and the Nihon Mingeikan (Japan Folk Crafts Museum), as well as his designs for remodeling the craft galleries at the Ohara Museum of Art, are further expressions of his unique design sense.

Looking back at the totality of Serizawa's achievement, the viewer cannot but be struck by the richness of his powers of depiction, but even more remarkable was his ability to create decorative patterns out of his wide array of subjects, including the natural world, crafts and trades, everyday objects, stories, religious images, and written characters, drawing out their innate qualities in the process. He possessed a remarkable ability to use the kataezome process to make art that offers universal aesthetic satisfaction in works that are always strikingly fresh in both technique and expression but never give even a hint of crudeness or eccentricity. They can seem almost ordinary, yet they are imbued with a gentle, peaceful sensibility that both expresses and harmoniously transcends the artist's lively personality. Therein lies the greatness of Serizawa's work in the kataezome technique.

fig. 3 Munjado (pictorial ideograph) for *honor* or *integrity,* from the collection of Serizawa Keisuke, nineteenth century. Korea. Ink and colors on paper, dimensions unknown. Shizuoka City Serizawa Keisuke Art Museum.

In the Guise of Tradition *Serizawa Keisuke and His Eclectic Designs*

Terry Satsuki Milhaupt

With his vast personal collection of African masks, Korean paintings, Okinawan textiles, and Japanese craft objects, the celebrated stencil dyer Serizawa Keisuke was a cultural translator who produced in a Japanese idiom. His textile designs, though venerating Japanese precursors, drew from a visual repertoire that spanned cultural and temporal boundaries. Despite his eclectic approach, however, Serizawa has been both championed as a *mingei* (people's crafts) artisan and designated a Living National Treasure, thereby participating in two Japanese ideological systems that revere the preservation of distinct cultural practices and knowledge handed down from generation to generation — more commonly referred to as *tradition*.

While it is difficult to discern precisely how knowledge of other cultural traditions affected Serizawa's productions or whether his creations are hybrids incorporating elements from multiple processes and practices, his works are often lauded today as "traditionally" Japanese, even though they reflect aspects of other cultures. His *noren* (entrance curtain) from 1955 (see cat. 42), for example, disguises his cultural eclecticism. Within the white outlines of the Chinese character *fuku* (good fortune), the left half of the character comprises motifs of bamboo and the right side a peony. The palette is reminiscent of Okinawan *bingata* dye colors — vibrant yellows, reds, and blues. Serizawa is known to have studied and favored the Okinawan practice of cutting the stencils and dyeing

the fabrics himself, rather than relying on a division of labor between stencil cutter and dyer, the conventional practice in Japan. Serizawa's composition bears further visual and structural affinities with Korean *munjado* (combinations of characters and motifs). Indeed, Serizawa actively collected munjado, including examples like the one shown in figure 3, particularly from 1953 on, after much of his original collection was destroyed during World War II.

Serizawa's interest in Korea and his association with one of the founders of the mingei movement, Yanagi Muneyoshi, date from the late 1920s. The word *mingei,* an abbreviation comprising the first and last syllables of *minshūteki kōgei,* "people's crafts," was coined in 1925 by Yanagi, and as originally defined, this now freighted term had "the sense of 'the art of the common classes.' . . . *Mingei* consequently have two characteristics: the first is functionality, the second is ordinariness. In other words, objects that are luxurious, expensive, and made in very small numbers do not belong to this category. The makers of *mingei* objects are not famous people but anonymous craftspeople."[1] Yanagi later made exceptions for the creations of an emerging group of individual artist-craftspeople like Serizawa, a highly visible vanguard member of the mingei movement in the 1930s. Serizawa became a founding member of the Nihon Kōgei Kai (Japan Art Crafts Association) in 1955, and the following year he was designated

fig. 4 Maiwai (celebratory fisherman's coat) with auspicious motifs, from the collection of Serizawa Keisuke, twentieth century. Stencil dyeing and tsutsugaki (cone-applied paste resist) on cotton, dimensions unknown. Shizuoka City Serizawa Keisuke Art Museum.

fig. 5 Kyō katabira (garment for a deceased person) with Buddhist talismanic imagery, from the collection of Serizawa Keisuke, nineteenth century. Hand painting on hemp, dimensions unknown. Shizuoka City Serizawa Keisuke Art Museum.

a Living National Treasure by the Japanese government. Serizawa's works thus simultaneously venerated tradition and extolled innovation.

Serizawa's early designs reflect a preference for formats and stylistic expressions closely associated with Japanese standards. Some of his earliest works, dating from the 1930s, combine written characters with various motifs and strongly resemble the encircled stylized characters emblazoned on the backs of Japanese fishermen's coats (fig. 4) or crests denoting family lineages (known as *mon*). Other possible precursors from the Japanese design repertoire include talismanic devices seen on Buddhist garments (fig. 5) or calligraphic characters embedded within kimono designs, both of which were represented in Serizawa's personal collection.[2]

The increasing syncretism of Serizawa's designs becomes apparent when some of his earliest uses of combinations of written characters and motifs are compared with his works from the 1950s. One of

Serizawa's signature themes was his rendition of the forty-seven Japanese phonetic syllables, known as *iroha*, named for the first three syllables that begin a well-known poem. In an eight-leaf screen produced in 1940 (see cat. 5), Serizawa depicted individual sounds from the Japanese syllabary as stylized characters or motifs within circles in a style similar to that in other works from this period, albeit in a more spirited form. In Serizawa's 1958 rendition of the Japanese syllabary in screen format (see cat. 55), however, individual characters are no longer isolated and confined within circles but rather intermingle with motifs related through pronunciation. His designs from the 1950s are more vibrantly colored and less restrained in form than his earlier works.

Functional yet exceptional in design and more than ordinary: herein lies the tension epitomized by Serizawa's productions, which were promoted and marketed through department store exhibitions starting in the 1930s. In keeping with mingei tenets that

disavowed signatures and ciphers, Serizawa's works bore no emblazoned brand name.[3] His distinctive designs, however, became a signature of their own. Serizawa's subsequent acceptance of the Living National Treasure designation reinforced the elevated status of his works. Ultimately, he became a commercially successful artist producing recognizable and eminently marketable products, but they were not ordinary, nor were they "made by the many for the many."[4]

How then did Serizawa—whose later works were anything but anonymous, inexpensive, and collectively produced—navigate the ideological terrain that separates mingei objects from recognizable works produced by artists who attain government recognition and sponsorship? The debate regarding the role of the anonymous artisan versus the individual artist began in the 1930s and went increasingly public when the government instituted a system for designating Living National Treasures. The 1950 Law for the Protection of Cultural Properties was enacted in part to prevent the disappearance of skills in arts deemed to have historical or artistic value. It was later revised to include all arts bearing significant historical or artistic value, endangered or not. While the selection criteria remained opaque, the laws were amended in 1955 to emphasize three basic tenets: "artistic value, importance in craft history, and local tradition." Serizawa's was an exceptional designation. Beyond celebrating his works because they produced a painterly composition that "cannot be found in designs painted by hand," government authorities coined a new term, *kataezome* (stencil-picture dyeing), for his technique.[5] This neologism effectively acknowledges Serizawa's innovative, even transcendent, dyeing practices.

As a founding member of the Nihon Kōgei Kai, Serizawa presumably was cognizant of shifting attitudes toward "tradition." In 1955 the first board director, Nishikawa Tekiho, expressed his hopes for the organization as follows: "This association is not about

being hidebound by the word 'tradition,' nor simply worshipping the culture of the past. Our foremost goal is to promote works that make the best of both Japanese traditions and elements learned from foreign countries."[6] It would be naive to assume that the term *traditional* can be equated with qualifiers such as *unchanging* or *bound by national borders*. In either of these cases, materials, techniques, motifs, and formats would ossify and quickly lose their freshness and appeal. The paradox of mingei is that it promotes the suppression of the artist's individuality for the sake of preserving time-honored techniques and collective practices; yet some of its major proponents, like Serizawa, nevertheless produced highly individualistic, nontraditional works. Similarly, the Living National Treasure system promotes and preserves the traditional arts of Japan, yet even as the system acknowledges how artists bow to Japanese precedents, rarely does it recognize the myriad cultural borrowings and adaptations—Korean, Okinawan, European, and American—that reflect the wider world in which the artists conceive, produce, and sell their works. One might ask: How many generations must pass before a foreign novelty becomes part of a nation's "tradition"?

Serizawa as remembered in the cultural imagination represents an important transitional figure moving from the anonymity of the mingei artisan to the celebrated position of Living National Treasure as embodied in an individual craftsperson. While his works reveal polarities between tradition and innovation, everyday and extraordinary, inexpensive and costly, regional and international, anonymity and identity, their attraction may lie in their ability to extract essential elements from the visual arts and technical processes of various cultural practices and transform them, appearing fresh yet steeped in time-honored conventions. His commercial success made it impossible for him to remain an "unknown craftsman" and thereby adhere to the strict mingei

ideal, yet he ensured the longevity of certain motifs, techniques, and formats by cultivating a demand for his deliberate selections of eclectic motifs and techniques.[7] Later in life, he established a research institute to train apprentices in his paper-dyeing technique. His works link one generation of Japanese artisans to the next at the same time that they bridge cultural borders. Serizawa navigated the turbulent waters between tradition and innovation, steering a new course for successive generations of Japan's artist-designers.

Notes

1. Elisabeth Frolet, "Mingei: The Word and the Movement," in Japan Folk Crafts Museum, *Mingei: Masterpieces of Japanese Folkcraft,* exh. cat. (Tokyo: Kodansha International, 1991), 11.

2. For Serizawa's early works see Serizawa Chōsuke and Sugiura Kōhei, *Serizawa Keisuke no mojie* (Tokyo: Ribun shuppan, 1997), ills. 23 and 47. For calligraphic characters in kimono designs see Sharon Sadako Takeda, "Clothed in Words: Calligraphic Designs on Kosode," in Dale Carolyn Gluckman and Sharon Sadako Takeda, eds., *When Art Became Fashion: Kosode in Edo-Period Japan,* exh. cat. (Los Angeles: Los Angeles County Museum of Art, 1992), 155–79.

3. See Kim Brandt, *Kingdom of Beauty: Mingei and the Politics of Folk Art in Imperial Japan* (Durham, N.C.: Duke University Press, 2007), 109, and Uchiyama Takeo, "The Japan Traditional Art Crafts Exhibition: Its History and Spirit," in Nicole Rousmaniere, ed., *Crafting Beauty in Modern Japan: Celebrating Fifty Years of the Japan Traditional Art Crafts Exhibition,* exh. cat. (Seattle University of Washington Press, 2007), 27; on the lack of brand name see Yanagi Soetsu, "Works of the Artist and Mingei" (1961), trans. Mimura Kyoko, www.mingeikan.or.jp/english/html/works-of-artist-and-mingei.html (accessed November 2, 2008).

4. Yanagi Sōetsu, adapted by Bernard Leach, *The Unknown Craftsman: A Japanese Insight into Beauty* (Tokyo: Kodansha International, 1972), 103. As Kim Brandt points out, "Of the thirty-seven individual craftspeople who had been chosen as living national treasures by 1975, five were closely associated with the early *mingei* movement. (A sixth, Kawai Kanjirō, declined the designation.)" (Brandt, *Kingdom of Beauty,* 226).

5. Uchiyama, "Japan Traditional Art Crafts Exhibition," 27; Jan Fontein, ed., *Living National Treasures of Japan,* exh. cat. (Boston: Museum of Fine Arts, Boston; Chicago: The Art Institute of Chicago; Los Angeles: Japanese American Cultural and Community Center, Los Angeles, 1983), 22–23.

6. Quoted in Uchiyama, "Japan Traditional Art Crafts Exhibition," 29–30. Uchiyama notes that because of struggles between old and new factions, "in 1958, the word 'tradition' was omitted from the exhibition title," but "then in the following year, 1959, for the sixth exhibition, the word 'tradition' was put back in the title, which has remained unchanged ever since."

7. For comments on the "individual craftsman" and the "folk craftsman" see Yanagi, *Unknown Craftsman,* 105–6.

Crafting a Japanese Don Quixote

Matthew Fraleigh

While the migration of a text across linguistic and cultural boundaries may prompt a range of misreadings, omissions, and other "infelicities," the process also provides opportunities for creative reconfigurations of both written and visual sources. Serizawa Keisuke's *Ehon Don Kihōte* (A Don Quixote Picture Book; see cat. 9) is a particularly vivid instance of such adaptation. It was produced at the request of Boston accountant Carl Keller, who was an avid collector of *Don Quixote* editions and other related materials.[1] In 1929, Keller's desire to obtain copies of published Japanese editions brought him into contact with the collector and founder of the people's crafts movement, Yanagi Muneyoshi, who was then spending a year lecturing at Harvard. Yanagi put Keller in touch with his friend Jugaku Bunshō, a scholar of English literature, practitioner of traditional crafts, and pioneering bibliographer, who agreed to purchase Japanese editions of *Don Quixote* and send them to Keller. Between 1930 and 1934, Jugaku sent Keller some fifteen Japanese editions of *Don Quixote*. Several included illustrations, especially those intended for children, yet as he wrote in his second letter to Jugaku in 1930, Keller was disappointed that the designers of the Japanese editions had not used any uniquely Japanese techniques or forms of expression in the illustrations. One incident that was often illustrated was the famous windmill episode (vol. 1, chap. 8), yet Keller was dissatisfied with this because he was sure that windmills were not a traditional feature of the Japanese landscape.

In 1935, Keller's frustration finally led him to take a more proactive role: he asked his friend Jugaku to help him commission a new version. After consulting with the *mingei* (people's crafts) potter Kawai Kanjirō, Jugaku chose Serizawa Keisuke for the task, and the illustrations were completed in October 1936.

Serizawa produced *Ehon Don Kihōte* in the manner of a *tanrokubon* (red-and-green book), a type of illustrated text that was printed in Kyoto in the first half of the seventeenth century.[2] The tanrokubon genre fused woodblock printing with hand-illustration techniques, making use of only a few colors, which were added by hand to highlight the bold outlines of a monochrome printed image. Instead of a woodblock, Serizawa used a stencil to apply the black outline. He added just three colors: a vermilion shade of red, a metallic shade of green, and a bright yellow. Each of the seventy-five copies that were printed is enclosed within a sturdy indigo rectangular case ornamented with golden dots. Affixed to the upper left of the top side of the case is a strip of paper that gives the title in a distinctively angular script that Serizawa produced with stencils. Even more than the unusual lines of the script, what would have been most striking to a Japanese reader was Serizawa's choice of syllabary for the title. With rare exceptions, Western-language terms are written in the more angular *katakana* syllabary, yet Serizawa chose instead to use the more cursive *hiragana* syllabary, which is used predominantly for indigenous terms. Though it might seem trivial,

fig. 6 Serizawa Keisuke, "Don Quixote, of a village in La Mancha, in the country of Spain," from *Ehon Don Kihōte*, vol. 1, chap. 1, 1936. Paper stenciling and hand painting on paper. Tōhoku Fukushi University Serizawa Keisuke Art and Craft Museum.

fig. 7 Serizawa Keisuke, "Defeated by the Knight of the White Moon (who is actually the bachelor), he vows to return home," from *Ehon Don Kihōte*, vol. 2, chap. 64, 1936. Paper stenciling and hand painting on paper. Tōhoku Fukushi University Serizawa Keisuke Art and Craft Museum.

fig. 8 Serizawa Keisuke, "He enters a cave and is witness to its wonders," from *Ehon Don Kihōte*, vol. 2, chap. 23, 1936. Paper stenciling and hand painting on paper. Tōhoku Fukushi University Serizawa Keisuke Art and Craft Museum.

Serizawa's choice of hiragana was one means by which he could realize the full domestication of *Don Quixote* that Keller sought.

The book has a red lacquer cover decorated with a gold pattern, the paper is fine handmade Japanese paper, and the volume is bound in the style known as *fukurotoji,* in which each page is a foldout printed on one side only. Jugaku delegated production of the book almost entirely to Serizawa, although others worked on specific tasks, such as the production of the cover and binding.[3] The first of the book's thirty-one images portrays Don Quixote engrossed in his reading of chivalric romances, as described in the first chapter of the novel (fig. 6). In most of the text's illustrations, Don Quixote appears fully accoutered in a suit of armor, but here he is shown wearing a kimono, with a fan in his left hand. Perhaps reflecting his immersion in fantasies of knight errantry, he maintains his place in the book with his right hand while his gaze focuses elsewhere. A sword is shown attached to his waist, and other martial equipage lies close at hand. Numerous books bound in the Japanese style, some opened, are strewn around, an untied scroll appears rolled up in the foreground, and several more scrolls can be seen in the background.

In this and other illustrations, the architectural features, objects, and costumes and hairstyles of the figures suggest an early Edo-period (1615–1868) setting, but the medieval period (late twelfth to late sixteenth century), the setting for the war tales that have captured Quixote's imagination, is also nostalgically invoked by the presence of certain archaic forms of military dress. Don Quixote appears throughout the book with the samurai's distinctive topknot and is usually shown in full samurai armor, wearing a helmet complete with *kuwagata* (hoe-shaped) ornamentation, one of the most prevalent forms of decoration for the helmets of Japanese warriors from the medieval period onward. The care with which Serizawa selected appropriate elements of Japanese material culture is evident in figure 7, which shows Don Quixote's ultimate confrontation with his nemesis, the Knight of the White Moon, who fittingly sports a helmet of the *mikazuki* (crescent-moon) type. To solve the windmill problem that so preoccupied Keller, Serizawa turned it into a waterwheel!

All the figures are shown in modes of dress appropriate to their analogous social class in Japan.[4] Sancho Panza appears in the humble garb of a porter, often carrying a bag suspended from a pole. The priest appears as a Buddhist priest, wearing a black robe and a rounded cap. The female characters all wear kimonos, varying in degrees of elaborateness depending on their social station. The Basque woman, for example, travels in a palanquin, and the duchess has attendants who carry a parasol to shield her from the sun. Serizawa also introduced several items associated with Japanese religious practice and East Asian beliefs about the supernatural. In figure 8, which depicts Don Quixote's fantastic experience in the subterranean Cave of Montesinos, the warden of the cave is shown with a crooked staff, a flowing beard, and loose white robes, as if he were a Daoist immortal. Similarly, when Don Quixote retreats to the Sierra Morena Mountains in order to undergo his penance in imitation of the fictional knight-errant Amadís de Gaula, Serizawa depicts him as though he were engaged in Buddhist ascetic practice, clothed only in a loincloth and seated in meditation on a rock beside a waterfall.

In addition to translating costumes and material artifacts into their Japanese analogues, Serizawa also drew upon a variety of traditional Japanese expressive styles. In several of the images that depict interior scenes, for example, he made use of the *fukinuki-yatai* (blown-off roof) technique to show the interior of a building from a bird's-eye, diagonal vantage point. Another traditional technique was the inclusion of *suyari-gasumi* (trailing mist), stylized lines of mist that hang horizontally across the length of the image. In some cases, such as the scene

in which the books of chivalry are burned (fig. 9), these lines may simply construct a frame through which the action is glimpsed. In other cases, they stretch across the middle of the image and can serve to divide two scenes separated by time or place. In figure 10, for example, these allow the depiction of Don Quixote's reception at the home of the duke at the top of the picture and Sancho Panza's subsequent conversation with the duchess in the lower half.

After Serizawa completed the images for *Ehon Don Kihōte,* he exhibited several of them at the opening ceremonies of the Nihon Mingeikan (Japan Folk Crafts Museum) in Tokyo in October 1936. As Jugaku would later recount, Serizawa's Japanese version of *Don Quixote* passed the ultimate test when a printing sample was sent to Keller. Apparently the sample arrived in Boston without much in the way of an explanatory letter, for upon receiving it, Keller immediately made inquiries of Tomita Kōjirō, a curator at the Museum of Fine Arts, Boston, to help him identify the marvelous image that had just arrived from Jugaku. So complete was Serizawa's transformation that Keller failed to recognize the print he received as

being part of the series he had commissioned. *Ehon Don Kihōte* was published by Jugaku's private press, Kōjitsuan, in 1937.

Exoticism may well have been part of the motivation for Keller's project, but whether he was conscious of it or not, the idea of transforming Don Quixote into an Edo-era samurai was a curiously appropriate one. The Edo period, in which Japan was under the control of the Tokugawa shoguns, was a time of unprecedented peace and stability. This meant that for more than two centuries the members of the elite warrior class, whose ostensible purpose was to defend the realm, had little opportunity to make use of their martial skills. Nevertheless, it was a time when elaborate theories of *bushidō,* "the way of the warrior," were propounded—often by men who, like Don Quixote, had never seen battle themselves and could only dream about it.[5]

fig. 9 Serizawa Keisuke, "Numerous books of chivalry being reduced to ashes," from *Ehon Don Kihōte*, vol. 1, chap. 6, 1936. Paper stenciling and hand painting on paper. Tōhoku Fukushi University Serizawa Keisuke Art and Craft Museum.

fig. 10 Serizawa Keisuke, "The nobles, enthralled by the tales of master and squire," from *Ehon Don Kihōte,* vol. 2, chaps. 31–33, 1936. Paper stenciling and hand painting on paper. Tōhoku Fukushi University Serizawa Keisuke Art and Craft Museum.

Notes

This brief essay is based in part upon a longer article I wrote entitled "El ingenioso samurai Don Kihōte del Japón: Serizawa Keisuke's *A Don Quixote Picture Book*," which appeared in *Review of Japanese Culture and Society* 18 (December 2006): 87–120. I would like to thank Josai University for agreeing to let me revise and reprint portions of it here.

1. The book was reprinted in another limited edition of twenty-five soon after its initial appearance in 1937. Forty years later, Serizawa revisited the material and published *Shinpan Ehon Don Kihōte* (New Edition: A Don Quixote Picture Book).

2. For a discussion of the form, see Yoshida Kogorō, *Tanrokubon: Rare Books of Seventeenth-Century Japan,* trans. Mark Harbison (Tokyo: Kodansha International, 1984).

3. See Jugaku Bunshō, "The Origins of *A Don Quixote Picture Book*," trans. Mika Yoshitake, *Review of Japanese Culture and Society* 18 (December 2006): 121–31.

4. This aspect of the pictorial representations in *Ehon Don Kihōte* is shared with many of the illustrated editions of *Don Quixote* that proliferated over the centuries in Europe. See Rachel Schmidt, *Critical Images: The Canonization of "Don Quixote" Through Illustrated Editions of the Eighteenth Century* (Montreal: McGill-Queen's University Press, 1999), 6–7, 89–125.

5. Keller would surely have been familiar with Nitobe Inazō's turn-of-the-twentieth-century *Bushidō: The Soul of Japan,* a book first published in English that further reinvented this invented tradition, replete with analogies to European chivalry.

106

Serizawa Keisuke and Okinawa

Amanda Mayer Stinchecum

Serizawa Keisuke described his first sight of a *bingata* paste-resist dyed wrapping cloth from Okinawa as a transformational experience that altered his approaches to color, formal composition, and theme. Bingata is a class of Ryukyuan or Okinawan textiles decorated by using a rice-derived resist paste and brilliant pigment colors supplemented by natural dyes.[1] Bingata includes two methods: freehand paste-resist dyeing (*nuihichi* in Okinawan) and paste-resist stencil dyeing (*katachiki*). Katachiki robes were worn by royalty, nobility, and the upper echelons of the gentry. Nuihichi was used for wrapping cloths (*uchikui*) by all social classes except the poorest commoners to carry food boxes, gifts, and other items, and for backdrop curtains at village festival performances. The Ryukyu Islands, at the southern end of the Japan archipelago, constituted the kingdom of Ryukyu until annexed by Japan in 1879. Most of these islands are now part of Okinawa, Japan's southernmost prefecture. Okinawa is also the name of the main island of the prefecture.

In 1928, Serizawa encountered his first example of bingata, a nuihichi wrapping cloth in a display organized by Yanagi Muneyoshi, founder of the *mingei* (people's crafts) movement. The uchikui embodied the strength of line, color, and composition that Serizawa praised in bingata. When he later saw many examples of stencil-dyed bingata at the Nihon Mingeikan (Japan Folk Crafts Museum), he received a "strong shock," according to his own account, and determined to

pursue stencil-dyed bingata as his life's work.[2] Two stylistic features of Okinawan bingata had appeared in Serizawa's work even before his first trip to the islands in 1939: a rhythmic repetition of motifs and the use of brilliant pigment colors. Repetition is inherent in the technique of stencil dyeing, but its use in bingata gives fluidity to many overall patterns, as seen in a fragment of a white cotton robe animated by swirling peonies (fig. 11), which may date to the nineteenth century. The pliant but forceful grace of bamboo and banana leaves, recurrent themes of Serizawa's work, particularly lend themselves to this rhythmic treatment.

When Yanagi traveled to Okinawa in April 1939, Serizawa accompanied him, his first visit to the prefecture. Serizawa spent more than two months there, receiving intensive training under two bingata masters whose workshops had survived the loss of Ryukyuan court patronage. During a second visit, in March 1940, he conducted a survey of bingata textiles in preparation for the publication of *Ryūkyū no katachiki* (Stencil Dyeing of Ryukyu). Ryukyuan textiles dominated his work into the mid-1950s, and their influence persisted into the following two decades in more subtle ways.

fig. 11 Fragment of a white bingata robe with design of peonies, from Okinawa, probably nineteenth century. Stencil dyeing on cotton, 19⅝ × 14 in. (50 × 35.6 cm). Suntory Museum of Art.

fig. 12 Serizawa Keisuke, Six-leaf screen with map of Okinawa Island and off-islands, 1940. Stencil dyeing on silk, 66 × 72 in. (170 × 183 cm). Victoria and Albert Museum, London.

fig. 13 Fragment of a white bingata robe with polychrome design, from Okinawa, second half of the nineteenth century. Stencil dyeing on cotton, 26 × 16¼ in. (66 × 41.3 cm). Suntory Museum of Art.

After his two-month stay in 1939, Serizawa dramatically increased his use of medium tones of indigo and the vibrant pigment colors of red (vermilion) and yellow (orpiment and yellow ochre) (see cats. 52, 81). A six-leaf screen (fig. 12) depicting a map of Okinawa Island reflects a number of elements he adapted from bingata. In traditional Okinawan bingata, overlays of luminous vegetable dyes such as yellow *fukugi* (*Garcinia spicata* Hook) and red sappanwood sometimes intensify background pigment colors. Shading with darker pigments enlivens bingata forms in ways that do not always accentuate the three-dimensionality of the object depicted but emphasize its decorative flatness. Serizawa's fondness for such shading is apparent in many of his works, including those that reflect no other obvious Okinawan influence (see cats. 34, 46, 57, 85). A strong horizontal emphasis structures many bingata pieces, exploiting the horizontality inherent in stencil dyeing that Serizawa deployed to great effect in some

of his kimonos (see cats. 66, 71). He was also influenced by larger-scale bingata patterns, such as those worn by Ryukyuan royalty, where horizontal composition is combined with bilateral symmetry (see cats. 61, 67, 70), sometimes imparting a static quality to his designs.

In addition to these stylistic differences, the bingata process also varies technically from the stencil dyeing of Japan's larger islands. In Okinawan bingata, all stages of the dyeing process were by custom executed by one person — or at least within one workshop. In the rest of Japan, stencil making was a completely separate industry from textile dyeing.[3] Control of the entire bingata process by one person made possible a spontaneity, both in pattern and in line, that was absent elsewhere in Japan (Serizawa noted that in cutting stencils, his knife often diverged from his underdrawing). Moreover, in bingata, individual motifs are first painted in by hand and the ground color is dyed afterward. This often results in uneven white outlines, in which the covering resist paste extends beyond the precise boundaries of each motif, as in catalogue 17. Although a Japanese dyer might view this as simple sloppiness, to the nonprofessional eye these white outlines enliven the finished design. In Japanese paste-resist dyeing, the ground is dyed first, leaving no accidental white outlines.

Unlike bingata made under the Ryukyu monarchy, which typically portrayed Japanese motifs, Serizawa's bingata made use of Okinawan subject matter, particularly during the two decades following his first trip to the island. He was especially fond of local landscapes, urban views, and scenes that incorporated artisans at work (see cats. 61, 74). Villages and townscapes include views of the Naha market and other local landmarks (see cats. 26, 61), while miniature landscapes interspersed with individual motifs scattered over a blue or white background feature in many bingata textiles (fig. 13) and are often seen in Serizawa's compositions. Even in the 1960s and later, when he had moved away from a style based on traditional bingata, he still referred to

Okinawan subjects with a kind of nostalgia, notably in two two-leaf screens depicting Okinawan artifacts, one made in 1970, the other in 1971.[4]

One of Serizawa's best-known kimonos (see cat. 6) echoes a Ryukyuan prototype (fig. 14) that depicts pavilions, stone walls, water, a torii shrine gate, and bridges. A stencil of nearly identical pattern (fig. 15) bears a date equivalent to 1826. It was common prac-

tice in bingata workshops to reuse earlier designs in cutting stencils. The horizontal format of the stencil reinforces the horizontality of the pictorial composition. Serizawa's kimono portrays the Japanese papermaking village of Ogawa and embodies a number of traditional bingata characteristics, including rhythmic repeats of landscape elements, horizontal emphasis, bright colors, and red-yellow shading. Many of Serizawa's other works presented Japanese scenes and subjects in a recognizably Okinawan mode (see cats. 25, 56, 80).

Following his designation as a Living National Treasure in 1956, Serizawa made five more trips to Okinawa. These postwar visits seem to have been occasions to reflect on the strengths of Okinawan bingata and its future in those islands. In an interview with *Okinawa taimusu* (Okinawa Times) during his 1958 stay, Serizawa described the appeal of bingata and its superiority to Japanese paste-resist dyeing, speaking directly from his immersion in the process.[5] In Japanese surface dyeing, he explained, "the design comes first, and the dyeing process follows. . . . In *bingata,* color and pattern are not separate entities. . . . The maker pours equal effort into pattern, stencil and color. It begins with the design, and then, as the power of the stencil, the cloth, the dyeing . . . are added, a single work comes into being." Serizawa's attitude toward contemporary bingata in Okinawa differed strikingly from that of his cohorts, who attempted to remake local crafts according to Yanagi's vision. Serizawa believed in a twofold approach to making bingata. He supported the preservation in Okinawa of the classical techniques but felt strongly that if bingata became removed from everyday life, it would not survive, except as a hobby. He urged textile students to take a creative approach to bingata, even if it meant using supplementary chemical dyes. In spite of the dramatic beauty of classical bingata, this has not really happened. Today, bingata production is confined to three

fig. 15 Bingata stencil with landscape design from Okinawa, inscription dated to 1826. Paper, 7½ × 16½ in. (19 × 42 cm). Okinawa Prefectural University of Arts.

Notes

1. See Barbara B. Stephan, "Bingata Dyeing of Okinawa," in Reiko Mochinaga Brandon and Barbara B. Stephan, *Textile Art of Okinawa* (Honolulu: Honolulu Academy of Arts, 1990), 7–9.

2. Serizawa Keisuke, "*Bingata* to watakushi [Bingata and I]," originally published in *Okinawa taimusu* (Okinawa Times), January 21, 1965, reprinted in Shizuoka Shiritsu Serizawa Keisuke Bijutsukan, ed., *Fushigi no kuni: Serizawa Keisuke to Okinawa* (Land of Surprises: Serizawa Keisuke and Okinawa; Shizuoka: Shizuoka Shiritsu Serizawa Keisuke Bijutsukan, 2006), 84.

3. See Susanna Campbell Kuo et al., *Carved Paper: The Art of the Japanese Stencil* (Santa Barbara, Calif.: Santa Barbara Museum of Art and Weatherhill, 1998), 45–75. See also the essay by Shukuko Hamada in this catalogue.

4. Serizawa Keisuke Bijutsukan, *Fushigi no kuni,* 56–58.

5. Okinawa Daihyakka Jiten Kankō Jimukyoku, ed., *Okinawa daihyakka jiten jōkan* (An Encyclopedia of Okinawa), vol. 1 (Naha: Okinawa Taimususha, 1983), 552; Serizawa's description was originally published in *Okinawa taimusu,* June 29, 1958, cited in Serizawa Keisuke Bijutsukan, *Fushigi no kuni,* 100n32; Amanda Mayer Stinchecum, "Yaeyama ni okeru minsā-to kankō kaihatsu [Minsā and Tourism Development in Yaeyama]," in Hateruma Eikichi, ed., *Minsā zensho* (All About Minsā; Ishigaki, Okinawa: Nanzansha, 2009); Kim Brandt, *Kingdom of Beauty: Mingei and the Politics of Folk Art in Imperial Japan* (Durham, N.C.: Duke University Press, 2007), 220.

areas: finely made kimonos primarily for Japanese trade, chemically dyed stage costumes, and tourist souvenirs.

Serizawa turned away from the strong impact of Okinawan bingata and island themes after his designation in 1956. His palette became more subdued, his compositions abstract and static, with stronger vertical emphasis. In both subject matter and style his work increasingly reflected the influence of his international travels and collecting, as well as a sensibility common to many areas of Japanese graphic design during the 1960s and 1970s. Serizawa's bingata legacy is most evident in the continuing production of stencil-printed papers, paper-covered accessories, and calendars. In Okinawa the superb kimonos of Fujimura Reiko, for example, embody a delicacy and balance of pattern and color all her own, one that appeals to customers throughout Japan. But the boldness, vibrancy, and inventiveness of Serizawa's early work may have been too idiosyncratic and brilliant to become part of the mainstream, either in Okinawa or in the rest of Japan.

fig. 16 Serizawa Keisuke, Magazine covers: *Kōgei*, issues 10, 11, 12, 1931. Stencil-dyed cotton, each 8⅞ × 6 in. (22.6 × 15.3 cm). Starr East Asian Library, Columbia University.

Serizawa Keisuke and the Mingei Movement

Kim Brandt

Serizawa Keisuke is often identified as a *mingei,* or "people's crafts," artist. He is invariably one of those named in the short list of celebrated *kojin sakka* (artist-craftspeople) who congregated around the collector and writer Yanagi Muneyoshi during the 1920s and 1930s, and whose intertwined careers helped define the mingei movement. Along with such iconic figures as the potters Hamada Shōji, Kawai Kanjirō, Bernard Leach, and Tomimoto Kenkichi, the printmaker Munakata Shikō, and the lacquerer and woodworker Kuroda Tatsuaki, Serizawa belonged to the inner circle of artists who worked closely with Yanagi and others devoted to the cause of preserving, promoting, and re-creating Japanese (and East Asian) mingei.[1] Nor did Serizawa ever break openly with Yanagi and the mingei group, as did Tomimoto in the 1930s, for example. Unlike Munakata, who became an international star in the 1950s, or Leach, who worked mostly in England, he remained closely tied to the Tokyo-based Japan Mingei Association throughout his career. Yet like these men Serizawa retained a certain independence; something set him at a slight remove from the mainstream of mingei activism, even as it might be argued that his work was indispensable to it.

Serizawa first met Yanagi in 1927. Yanagi was brought to his home in Shizuoka by the wealthy collector Takabayashi Hyōe, apparently in order to view Serizawa's collection of *ema* (small painted wooden plaques customarily offered at Shinto shrines).

Already in his early thirties, Serizawa was by this time well established as a commercial designer and artist, having worked for several years supervising dye, lacquer, and wood design at prefectural institutions in Shizuoka, and also having won several prestigious national prizes for poster design, newspaper advertisement design, and *shugei* (hobby-craft) design. Despite Serizawa's shared interests with the mingei group, several aspects of his background would have militated against any immediate or full incorporation within it as it had begun to form under Yanagi's aegis in Kyoto and Tokyo. Unlike that of Hamada and Kawai, who were at the center of the group, Serizawa's admiration for older, indigenous East Asian handicrafts does not seem to have extended to a complete acceptance of the antimodernist, antiindustrial principles articulated and preached by Yanagi in his emerging handicrafts theory. Serizawa had been trained, after all, as a modern print artist and designer, and at no point in his career does he seem to have felt any particular aversion to modern technology (such as the photogravure process) or machine production. Just as important, perhaps, was Serizawa's relationship to Takabayashi—and more generally Serizawa's place within a local network of notable men in the Shizuoka region. Takabayashi was one of Serizawa's most important early patrons, and the two seem to have kept up cordial relations even after Takabayashi's quarrel with Yanagi in the early

1930s — a falling out that concerned at least in part a rivalry between the two older men for influence over Serizawa.[2]

For the historian of mingei, it only adds to Serizawa's enigmatic, slightly marginal air that of all the mingei *dōjin* (fellows, comrades), he was the most reticent in print about his opinions and ideas. He published only a handful of brief articles in the main mingei periodicals and left behind no completed memoirs or collected essays. Tellingly, *Serizawa Keisuke zenshū,* a thirty-one-volume authorized compendium of Serizawa's oeuvre completed in 1983, consists almost entirely of reproductions of his prints and designs, with very little text. Considered from another perspective, however, Serizawa was anything but marginal to the mingei movement. As a designer and printer, if not author, his stamp was literally everywhere in the published materials of the Japan Mingei Association and its central figures. Indeed, one might go so far as to say that Serizawa was the mingei movement's unofficial graphic designer and that it was he as much as anyone who determined its aesthetic, or look.

Serizawa's career as a designer of books and book covers is said to have taken off when he was commissioned by Yanagi to produce the covers for the first twelve issues of the monthly magazine *Kōgei* (Craft), which began publication in 1931 (fig. 16; see also cat. 11). It was Serizawa who came up with the idea of producing four different designs for the cover and using each for three consecutive issues, in different colors. Yanagi took the matter of *Kōgei*'s binding and covers seriously; as he put it in his editorial postscript for the first issue, "There have been bindings made of printed cloth before, but I believe this is the first time that both text and pattern [on the cover] have been produced completely by block-print dyeing. We hope very much that this develops as a unique form of Japanese bookbinding. If this spreads, it will be epoch-making in book design. This is because it has not been attempted in China or in the West."[3] Epoch-making or not, Serizawa's distinctive designs for book and magazine covers soon became ubiquitous among mingei publications. In addition to designing covers for later issues of *Kōgei* and other mingei periodicals, he designed and produced the bindings and covers for numerous books by Yanagi and several other prominent figures within mingei circles, such as Jugaku Bunshō and Shikiba Ryūzaburō (see cats. 10, 15).

Nor was Serizawa's influence on mingei publications limited to bindings and covers. He was frequently called upon, for example, to provide the decorative and sometimes illustrative patterns, figures, and *koma-e* (emblems) that appeared on title pages, on tables of contents, and often at the beginning or end of articles or chapters (fig. 17). In addition, during the formative early decades of the mingei movement Serizawa designed a good deal of the more ephemeral promotional material put out by the Japan Mingei Association, the mingei retail store Takumi, and the Nihon Mingeikan (Japan Folk Crafts Museum). He designed and produced, often without attribution, posters, maps, pamphlets, floor plans, calendars, advertisements, signs, and more. One important result was that even as the Mingei Association grew, and as the projects and organizations associated with it multiplied during the 1930s and beyond, Serizawa provided a unified visual aesthetic in the graphic media through which mingei activists communicated with one another and with the public at large. Serizawa even seems to have been responsible for designing the crests or trademark images associated with each of the three main mingei institutions, along with the diagram of a tree that first began to appear in the late 1930s to link the three as part of a larger entity (fig. 18).[4]

There is another sense in which Serizawa helped to publicize mingei, at a time when the term — and the ideology associated with it — were still new and unfamiliar to the vast majority of Japanese.

fig. 17 Serizawa Keisuke, "Hokushi no mingei" (People's Crafts of Northern China), illustration for Shikiba Ryūzaburō, *Mingei to seikatsu* (People's Crafts and Daily Life; Tokyo: Hokkō Shobō, 1943), 40. Titled "Sentō chiku no kōgei undō" (The Craft Movement in the War Zone), this section describes an exhibition of local Chinese crafts held in Beijing. Collection of the author.

fig. 18 Tree diagram, *Gekkan mingei* 2 (May 1939), unpaginated. The three symbols represent the Nihon Mingeikan (Japan Folk Crafts Museum, center), the Japan Mingei Association (right), and the Takumi store in Ginza, Tokyo (left). Collection of the author.

Unlike most of the other mingei artist-craftspeople, Serizawa continued to work on a variety of other, non-mingei-related projects. His book and magazine covers, for example, graced a wide assortment of publications, ranging from literary works (including many by Kawabata Yasunari; see cat. 14) to medical and religious journals to the annual albums produced by a private group that collected New Year's postcards.[5] It is probable that many of those who commissioned work from Serizawa first became aware of him because of his association with *Kōgei*, and with the mingei group more generally, but his willingness to turn his hand to jobs unconnected to folk crafts may have served to disseminate the mingei movement's visual aesthetic among a larger audience.

Similarly, while Serizawa's work in textile design certainly developed in ways (discussed by Amanda Mayer Stinchecum and Terry Satsuki Milhaupt in this catalogue) that were informed by the collective interests and agenda of the mingei group, at the same time he continued to explore some of the more overtly commercial possibilities to be found in women's fashion and through women's magazines, which he had discovered before his involvement with Yanagi. Here too Serizawa's relative autonomy from the mingei movement, based in part on his background in commercial art and industrial design, redounded to its benefit. One of the reasons why the Japan Mingei Association was able to grow and flourish during the 1930s and beyond was that mingei found an enthusiastic audience, and market, among a rapidly growing population of middle-class women. Not only did Serizawa bring his commercial design acumen to the efforts by mingei activists to find and broaden markets for folk-craft objects and publications, but his own textile works — which included vividly decorative obis, kimonos, and household items such as floor cushions and bedding — were often designed with an

eye to the well-heeled, stylish female consumer. It is not surprising, therefore, that Serizawa and his work were singled out for special attention in the June 1941 issue of the upscale women's fashion magazine *Fujin gahō* (Ladies' Graphic). Serizawa designed the cover and was also the subject of a lavish pictorial feature inside as a *seikatsu no dezainaa* (designer of everyday life). Yet even though the issue's focus was on Serizawa and his work, the mingei movement came in for its share of publicity as well; Yanagi wrote a brief introductory essay, and the main article referred frequently to Serizawa's association with him and the other leading mingei activists.[6]

The article in *Fujin gahō* intimated several times that Serizawa owed his success to his work with and for the mingei activists. In particular, Shikiba Ryūzaburō was quoted to the effect that the 1931 commission to design covers for the magazine *Kōgei* represented a turning point in Serizawa's career.[7] Perhaps it is not too much to add that by the same token the mingei movement owed at least some of its success to Serizawa, and that 1931 was a turning point for all concerned.

Notes

1. On the history of the mingei movement see Kim Brandt, *Kingdom of Beauty: Mingei and the Politics of Folk Art in Imperial Japan* (Durham, N.C.: Duke University Press, 2007).

2. I have taken the 1927 date for the meeting between Yanagi and Serizawa from Suzuki Naoshi, *Maboroshi no Nihon Mingei bijutsukan: Enshū no mingei undō to sono gunzō* (The Phantasmatic Japan Mingei Art Museum: The Mingei Movement and Its Group in Enshū; Iwata: Shūgetsu Bunka Shūdan, 1992), 35–36. According to Suzuki, the more commonly cited date of 1926 is mistaken. For other details on Serizawa's career, see the Chronology. Yanagi's classic statement of his theory appears in his "Kōgei no michi [The Way of the Crafts]," first published serially in 1927–28 in the magazine *Daichōwa*. The quarrel is discussed by Suzuki. According to him, the relationship ended on a train headed west from Tokyo when Yanagi, in response to Takabayashi's praise of Serizawa's recent work, retorted, "You are in no position to judge it" (Suzuki, *Maboroshi no Nihon Mingei bijutsukan*, 33).

3. Yanagi Muneyoshi, "Henshū yoroku [Editorial Notes]," *Kōgei* 1 (January 1931): 57.

4. It is difficult to attribute many of the promotional materials with any degree of certainty. However, Serizawa is given credit for this particular design in *Serizawa Keisuke zenshū*, and certainly it is rendered in a manner consistent with many of his other designs. See *Serizawa Keisuke zenshū*, vol. 25 (Tokyo: Chūōkōronsha, 1982), 66.

5. See the reproductions and list of covers (ibid.), along with the essay by a member of the postcard collectors' group, Takei Takeo (ibid., 162–64).

6. Yanagi Muneyoshi, "Serizawa-kun no sonzai [Mr. Serizawa's Work]," unpaginated, and Tanaka Toshio, "Seikatsu no dezainaa: Serizawa Keisuke [Serizawa Keisuke: Designer of Everyday Life]," *Fujin gahō* 449 (June 1941): 15–22.

7. Quoted in Tanaka, "Seikatsu no dezainaa," 16.

The Art of Serizawa Keisuke

Shukuko Hamada

In 1956 the Japanese government awarded Serizawa Keisuke the title Holder of an Important Intangible Cultural Property, better known outside Japan by its more informal name, Living National Treasure. This honor was granted in recognition of his contribution to the stencil-dyeing technique now known as *kataezome,* a word invented by the Committee for the Preservation of Cultural Properties specifically for the award. The technique had evolved into something like its present form about 1600, as seen in a six-leaf screen of craftspeople at work painted by Kano Yoshinobu (fig. 19) that includes a depiction of the many processes involved, including sticking the cloth to boards, applying rice-paste resist using paper stencils, dyeing the cloth, washing away the resist, and finally hanging the cloth up to dry. In the past, the three processes of cutting the stencils, applying the resist design, and dyeing the cloth had each been carried out by a different craftsman, but when Serizawa revived stencil dyeing in the twentieth century he involved himself in every stage of production, from the initial sketch to the finished article.

Serizawa Keisuke was born in 1895 into a family of cloth merchants living in Shizuoka, a city in central Honshu (Japan's main island). From an early age he showed a talent for painting and dreamed of becoming a professional artist, but his family's declining fortunes forced him to study instead at the Design Department of the Tokyo Higher Industrial School. He spent the first ten years after his graduation seek-

ing out a future direction for his life and career, never staying long in the same job and spending much of his time sketching outdoors or teaching embroidery, knitting, and wax-resist dyeing to a local group of young women. At the ages of thirty-two and thirty-three, however, he had two life-changing experiences. The first of these was his meeting with Yanagi Muneyoshi, the philosopher and aesthetic theorist who was just then in the middle of his celebrated spiritual journey of rediscovery, first of Korean art and then, by extension, of East Asian art and thought in general. Yanagi eventually started to travel the length and breadth of Japan, seeking out and collecting ordinary utensils made by anonymous craftsmen and women in which he perceived a hitherto unappreciated beauty. This aesthetic insight resulted in 1925 in his coining the term *mingei* (people's crafts), an event that marked the foundation of the mingei movement. As he worked to promote the ideals of mingei, Yanagi continued to reflect on the nature of the beauty he found in everyday objects, giving public expression to his thinking in a series of articles entitled "Kōgei no michi" (The Way of the Crafts), published in 1927–28. Serizawa started to read the articles on his way to Korea, and the pro-

fig. 19 Kano Yoshinobu (1552–1640), Stencil-dyer's workshop, detail from *Shokunin zukushi* (A Complete Guide to the Trades), early seventeenth century. Ink and colors on paper, now mounted on a screen, 22⅞ × 17¼ in. (58 × 43.8 cm). Kita-in, Kawagoe City, Saitama Prefecture; Important Cultural Property.

fig. 20 Serizawa Keisuke, Fans. Stencil-dyed paper, dimensions unknown. Tōhoku Fukushi University Serizawa Keisuke Art and Craft Museum.

found impression they made on him is evident from an entry in his brief, unfinished autobiography: "[These articles by Yanagi] opened up whole new vistas onto the nature and meaning of the crafts. Reading them was a turning point in my life." Another reference, in a biography compiled by Shikiba Ryūzaburō (see cat. 10) in 1937, offers further evidence of the impact of Yanagi's ideas: "This was a moment of seismic change in Serizawa's thinking. Nagging doubts about the value of the crafts which had long troubled him melted away. At last he understood the true nature and purpose of craft production."[1]

The second life-changing experience came in 1928, when Serizawa saw a display of stencil-dyed textiles in *bingata* style from the islands of Okinawa and was captivated by the precision and clarity of the designs (applied using a single stencil) and the radiance of the colors. In 1939 he made good his vow to travel to Okinawa, where he deepened his love and appreciation of the bingata technique by undertaking a thorough program of practice and documentation. Serizawa grew ever more committed to his vocation as a crafts-man and stencil-dyeing artist, and from that time on he applied himself in earnest to his life's work, making mingei his guiding philosophy.

In his seminal article, Yanagi advocated the creation

of crafts that combine aesthetic appeal with practical function and possess several different types of beauty: the beauty that comes from everyday familiarity, the beauty of health and strength, the beauty of service-ability, the beauty of objects that move in harmony with their users' movements, the beauty of tradition, and the beauty of honesty and solidity. All the mingei artists experimented with different ways of realizing the ideals set out by Yanagi, but they were not always successful in confronting such problems as the rela-tion between the "unknown craftsperson" and the "artist-craftsperson" or the fact that many handmade craft items were no longer suited to changing tastes and modes of life. Despite these challenges, Serizawa managed to get to the heart of Yanagi's thinking and embody his ideals in many aspects of his life and work while always making allowance for contemporary developments.

So successful was Serizawa in demonstrating what it should mean to be an artist-craftsperson that Yanagi held him up as an example in two articles about the problem of the partnership between mingei philosophy and the individual artist. Among the posi-tive episodes from Serizawa's career cited by Yanagi were the instruction in dyed-paper design that he offered at the Prefectural Papermaking Institute in Ogawa (Saitama Prefecture) in 1935, his trip in 1944 to Kakunodate in Akita Prefecture, where he gave a course in designs for items made from cherry bark (a local material), and his founding in 1955 of the Ser-izawa Paper-Dyeing Research Institute, where young people lived together communally and devoted them-selves to the craft of dyeing (see cat. 16).[2]

Dyeing with paper stencils is a demanding process, requiring the artist to make the best use of an intractable and restrictive medium. The results can look awkward and mannered, but Serizawa managed to overcome these technical constraints to produce a large body of work that is relaxed, spontaneous, and

lively, its appealing warmth and cheerfulness making us want to have it around us and use it in our daily lives. Serizawa never missed an opportunity to sketch. He would draw vegetables and fruits before he ate them, and he included everything in his notebooks: people, animals, flowers, plants, scenes from everyday life, and the landscapes he saw on his travels. These sketches were later used as the raw material for the motifs depicted in his stenciled textiles and paintings. Serizawa also deployed his inventive genius to impressive effect by creating pieces decorated with script designs, such as the so-called *nuno moji*, characters shown as pieces of folded material fluttering in the breeze. Although letters and characters are often seen in the West as nothing more than symbols to communicate meaning, he was able to give them a life of their own, transforming them into autonomous, animate beings.

Serizawa's work is also remarkable for its breadth and variety. He produced articles for daily use, such as kimonos, obis, *noren* (entrance curtains), wall hangings, *furoshiki* (wrapping cloths used to carry food boxes, gifts, and other items), tablecloths, folding and nonfolding fans (fig. 20), calendars, and picture postcards; works with a purely aesthetic purpose such as screens, scrolls, and framed textiles and paintings; book covers, illustrations, and bookplates; commercial designs for items such as matchboxes, menus, posters, wrapping paper, *noshigami* (formal gift decorations), trademarks, and product labels; and designs for architectural fittings, including iron lanterns, store signs, theater curtains, ornamental hangings for temples, stained glass, and furniture, as well as hand-decorated ceramics and original paintings on paper, silk, glass, and wood.

The multifarious character of Serizawa's activities, which covered every aspect of daily life, could well have earned him the title of "designer" or "art director," and in this respect he invites comparison with an earlier artist, Ogata Kōrin (1658–1716). Born into a rich silk-merchant family in Kyoto, Kōrin took the early-seventeenth-century artist Tawaraya Sōtatsu as his model, adapting his predecessor's style and taking it in a new direction by endowing it with a less aristocratic, more plebeian spirit. Like Serizawa, Kōrin was active not just as a painter but also as a designer of textiles, lacquerware, and ceramics. In addition, to help promote his distinctive decorative style he made a wide range of everyday articles such as fans and incense wrappers.

Although widely separated in time, Ogata Kōrin and Serizawa Keisuke have several points in common. These include not only their highly varied output and strong influence on later generations but also their bold stylization of natural motifs and their ability to endow these with a fresh, spontaneous sense of life. They refused to be confined to a single narrow artistic sphere but constantly challenged themselves to devise novel creative forms that would embellish and decorate the everyday environment. In so doing, both men pointed to new ways of thinking about the role of the artist in society.

Notes

1. Yanagi Muneyoshi, *Yanagi Muneyoshi zenshū,* 22 vols. (Collected Works of Yanagi Muneyoshi; Tokyo: Chikuma Shobō, 1980–92), vol. 8; Serizawa Chōsuke, ed., "Jihitsu nenpu miteikō [An Incomplete Manuscript Autobiography by Serizawa Keisuke]," in *Tōhoku Fukushi Daigaku Serizawa Keisuke Bijutsu Kōgeikan zuroku* (Illustrated Catalogue of the Tōhoku Fukushi University Serizawa Keisuke Art and Craft Museum; Sendai: Tōhoku Fukushi University, 1989), 80–87; Shikiba Ryūzaburō, "Serizawa Keisuke nenpu [A Biography of Serizawa Keisuke]," *Kōgei* 76 (1937): 65–74.

2. Yanagi Muneyoshi, "Mingei to kojin sakka [Mingei and the Individual Craftsperson]," *Mingei* 72 (1958): 4–7, and Yanagi, "Saido mingei to sakka ni tsuite [Another Look at the Relationship Between Mingei and the Artist]," *Mingei* 74 (1959): 4–11.

The Kataezome Technique

Katazome, in which stencils are used with dye-resistant paste to create patterns on cloth, has a long history in Japan. In the past, the three processes of cutting the stencils, applying the resist design, and dyeing the cloth were each carried out by a different artisan. When Serizawa Keisuke revived the art in the twentieth century, however, he involved himself in every stage of production — the initial sketch, the cutting of the stencil, and the application of the dyes. In recognition of his innovation, the Committee for the Preservation of Cultural Properties created the term *kataezome* for his process.

CUTTING THE STENCIL

The design is drawn on thin paper or tracing paper and lightly adhered with wax to the stencil, which traditionally consists of several sheets of handmade *minogami* (paper manufactured from the pith of the paper-mulberry tree) glued together with persimmon juice (fig. 21). This stencil is then laid on a board of magnolia wood and the design is cut out using a small, two-edged knife.

APPLYING THE SILK NETTING

While the stencil pattern is being carved, certain areas are deliberately left unfinished in order to prevent cutouts from falling off and thin pieces from curling. These uncut areas are completed only after a loose silk netting has been applied to the top surface of the entire stencil and secured in place with lacquer (fig. 22). Once the netting has been applied and the unfinished areas have been fully cut out, the completed stencil can be safely removed from the design paper.

MAKING THE PASTE

Mochi (sweet rice) powder is boiled and then formed into dumpling-shaped cakes. These are boiled again and pounded in a mortar. The result is "raw paste," which is softened by adding rice bran, lime, and salt (fig. 23).

fig. 21

fig. 22

fig. 23

fig. 24

fig. 25

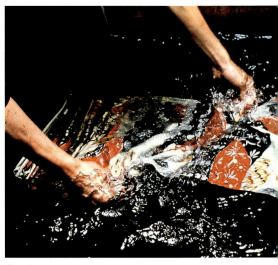

fig. 26

POSITIONING THE STENCIL ON THE CLOTH

A long board is completely covered with raw paste, which is first allowed to dry and then moistened with a damp brush. A length of undyed cloth is glued to each side of the board and a stencil, which has previously been stretched by thoroughly soaking it with water, is applied to the cloth. A spatula is then used to spread the resist paste evenly through the holes in the stencil (fig. 24). Next, the stencil is carefully shifted to other sections until the entire piece of fabric has been covered with the pattern.

COLORING

The vegetable colors are made by mixing the various pigments with *gojiru,* a concoction created by soaking soya beans in water overnight, grinding them up in a mortar, putting the resulting pulp into a bag, and squeezing out the residual liquid. These colors are then rubbed into the paste-free areas with a small brush (fig. 25).

WASHING

After the colors have dried and been fixed into the fabric, the cloth is soaked again in water (fig. 26). After the resist paste has softened and started to float off the surface, it is fully removed using a small, handheld broom. The cloth is then rinsed several times.

DRYING THE CLOTH

After the paste has been removed the cloth is stretched out full length to dry in the open air (fig. 27).

fig. 27

fig. 28

COATING WITH PASTE FOR GROUND-COLOR DYEING

When the ground color of the fabric is also to be dyed, the stenciled designs must be protected from the dye with a coating of paste. A cone made of paper strengthened with persimmon juice is filled with resist paste, which is then squeezed out to cover the stenciled designs (fig. 28).

DYEING THE GROUND COLOR

For indigo dyeing, the fabric is sprinkled with sawdust to prevent the resist paste from adhering to other sections. It is then stretched on a frame and dipped repeatedly in a vat of dye until the proper intensity of color is attained. For other colors, after the resist paste has dried the cloth is stretched out on a board and treated with a thin variety of gojiru. Then the dyes are applied by hand with a brush, starting at the ends and working toward the middle.

FINAL WASHING AND DRYING

The cloth is soaked a final time in water to remove all the paste and then stretched out full length to dry in the open air.

Chronology

1895

Born in Shizuoka City, central Honshu, second son of the draper Ōishi Kakujirō.

1913

In March the family home is destroyed by fire. Graduates from Middle School and joins the Design Department of Tokyo Higher Industrial School (later Tokyo Industrial University).

1916

Graduates from Tokyo Higher Industrial School and returns to the family home in Shizuoka.

1917

In February, marries Serizawa Tayo, also from Shizuoka City. Takes employment with Shizuoka Prefectural Industrial Research Institute; also attached to Shizuoka Prefectural Industrial School. His oldest daughter, Mie, is born.

1919

His son, Chōsuke, is born. Starts to collect ema (small painted wooden plaques customarily offered at Shinto shrines). Death of his mother-in-law.

1920

Death of his mother.

1921

Moves to the Design Department of Osaka Municipal Merchandise Showroom and is promoted from technician to senior technician with responsibility for regional industry, reaching the senior eighth grade within the organization.

1922

Resigns from his post and returns home, resuming his work with Shizuoka Prefectural Industrial School. Pays regular visits to the surrounding villages and countryside and immerses himself in botanical drawing. Organizes a group of young local women into the Konohanakai (Tree-Flower Club); they use his designs as the basis for a range of craft items. His attention is caught by a special issue of *Shirakaba* magazine devoted to Korean ceramics. Second daughter, Waki, is born.

1923

In September the Great Kanto Earthquake strikes eastern Japan. Abandons his attempt to win a commission to design a curtain for the Kabukiza Theater in Tokyo.

1924

Serizawa and his family are bankrupted by the failure of a hospital run by a relative for whom they had stood as guarantor and have to move into a rented house. Serizawa works on commissions for the decoration of store fronts, advertisements, festival floats, and similar projects. His father dies.

1926

Takes a job at Shizuoka Women's Vocational School. The Konohanakai wins first prize at an exhibition organized by the Shufunotomo publishing company.

1927

Accompanied by Takabayashi Hyōe and Uchida Rokurō, Yanagi Muneyoshi visits Serizawa at his home in Kitabanchō and views his collection of ema. Serizawa moves to Takajō-machi. An exhibition at the Kyūkyodō store in Tokyo gives him his first glimpse of traditional Japanese folk crafts. Goes with Suzuki Atsushi to Korea, where the two visit Seoul and the Pulguksa Temple in Kyongju. On the journey to Pusan, Serizawa reads and is greatly influenced by Yanagi Muneyoshi's series of articles "Kōgei no michi" (The Way of the Crafts), which opens his eyes to the potential of the crafts and changes the direction of his work.

1928

Designs and manages the Federation of Shizuoka Prefecture Tea Cooperatives display at the *Gotairei Kinen Kokusan Shinkō Hakurankai* (Exposition for the Promotion of Domestic Products in Commemoration of the Enthronement of the Showa Emperor) held in Ueno Park, Tokyo. Struck by a display of Okinawan bingata textiles in the exposition's Mingeikan (People's Crafts Pavilion), he starts visiting dyeing workshops in Shizuoka City and studying traditional stencil-dyeing techniques. Also visits Yanagi Muneyoshi's home in Kamigamo, Kyoto, and gets to know the textile artist and schoolteacher Aota Gorō and the lacquer artist Kuroda Tatsuaki.

1929

His first textile, a wax-resist dyed-linen wall hanging with a blue ground and a design of Chinese cabbages, is shown at the Kokugakai exhibition and wins a scholarship prize (see cat. 2). Visits Korea again.

1930

Moves to Sanbanchō, Shizuoka. Converts three houses in the bankrupt relative's hospital into a dyeing workshop, installs dye vats, and takes on an assistant. Shows ten dyed textiles at the Kokugakai exhibition, including some with vegetable and fruit designs, winning the "Mr. N." prize and becoming an associate member of the Kokugakai group.

1931

Designs the stencil-dyed covers for the first year's issues (see cat. 11) of the new magazine *Kōgei* (Craft). Becomes friendly with Shikiba Ryūzaburō (see cat. 10). Tours ceramic kilns in the Tohoku region (northeastern Honshu) and discovers the Nanbu style of ema during a visit to Hachinohe. Collaborates with Kuroda Tatsuaki in holding a joint selling exhibition of their work. Third daughter, Toshi, is born. Holds an exhibition in Tottori City.

1932

Includes book covers and slipcases in his display at the Kokugakai exhibition (see cat. 12) and becomes a full member of the group. Designs and makes covers for Shikiba Ryūzaburō's *Fan Hohho no shōgai to seishinbyō* (Van Gogh's Life and Mental Illness; see cat. 10). With Hiramatsu Minoru, Tonomura Kichinosuke, Yanagi Yoshitaka (nephew of Yanagi Muneyoshi), and other artists, takes part in an exhibition at the Daimai Kaikan Hall in Kyoto, where an early version of *Isoho Monogatari* (Aesop's Fables; see cat. 4) is warmly received. Issue 24 of *Kōgei* is devoted to his work.

1933

Holds a one-man exhibition in Dalian (China) and travels throughout Manchuria and Korea. Holds a second one-man show in Tottori. The potter Tomimoto Kenkichi and his wife visit Serizawa in Shizuoka and collaborate with him in dyeing experiments.

1934

Thanks to the generosity of Mizutani Ryōichi, Serizawa moves to Tokyo with his family and staff, setting up his home and workshop in Kamata machi, Kamata ku (present-day Ota-ku). Holds a one-man exhibition at the Takumi Craft Gallery, Tokyo. Makes his first iroha (syllabary) screen (for later examples, see cats. 5, 55) for exhibition at the Takashimaya Department Store.

1935

Helps with designs for furniture and other fittings for the Nihon Mingeikan (Japan Folk Crafts Museum) in Komaba, Tokyo. Becomes a part-time instructor at the Prefectural Papermaking Institute in Ogawa, Saitama Prefecture, teaching the design and manufacture of paper stencils. Yanagi Yoshitaka builds a new workshop on the same plot of land as Serizawa's and settles there. Serizawa is commissioned to create *Ehon Don Kihōte* (A Don Quixote Picture Book; see cat. 9).

1936

The Nihon Mingeikan opens. Completes *Wazome egatari* (The Illustrated Story of Japanese Dyeing; see cat. 8).

1937

Designs and manufactures *Ehon Don Kihōte* as well as the cover for Kawabata Yasunari's novel *Yukiguni* (Snow Country; see cat. 14). Following a quarrel between Yanagi Muneyoshi and the potter Tomimoto Kenkichi, Serizawa resigns from the Kokugakai, along with Yanagi, Hamada Shōji, Tonomura Kichinosuke, Yanagi Yoshitaka, and others. With Yanagi Muneyoshi and Kawai Kanjirō, visits Yamagata Prefecture to study local folk crafts and take part in talks on reviving the local economy.

1939

Travels to Okinawa with Yanagi Muneyoshi and others and learns the bingata technique at a workshop in Naha. On his return to Tokyo obtains plain ceramic wares from a wholesaler and experiments with red enamel decoration (*aka-e*). Holds a one-man exhibition at Hankyu Department Store in Osaka, displaying aka-e ceramics for the first time as well as a screen with a pictorial map of Okinawa (see figure 12 in the essay by Amanda Mayer Stinchecum in this catalogue).

1940

Second visit to Okinawa.

1941

Completes *Hōnen Shōnin eden* (The Illustrated Life of Saint Hōnen; see cat. 23). Travels to Yamagata Prefecture again to promote off-season craft manufacture at the Snowfall Region Farm Village Economic Survey Institute. Contributes designs for a planned dormitory for female workers at a spinning factory to *Gekkan mingei* (People's Crafts Monthly) magazine.

1942

Attached to the Naval and Aeronautical Industrial Company.

1944

Travels with Yanagi Muneyoshi to Kakunodate in Akita Prefecture to promote craft manufacture using cherry bark.

1945

Loses his house and all his possessions in the U.S. firebombing of Tokyo and takes refuge in the nearby Kinjōji temple before moving to Kugahara in Ōmori-ku and later lodging at the Nihon Mingeikan. In December, designs his first stencil-dyed calendar (see cat. 16).

1946

Lodges at Nakata Seibei's villa in Sannō, Ōmori-ku, Tokyo.

1947

Moves into an annex of the Murata residence in Minami-chō, Aoyama, Tokyo. Produces textiles with views of Okinawa. Becomes a professor at Tama College of Art.

1949

Becomes a professor at the Women's Arts College.

1951

Receives a roughly 18,000-square-foot plot of burnt-out land in Kamata from the Bureau of Finance. Moves the Hokuriku Bank's night watchman's huts and storage buildings to Kamata and uses them as a house and workshop.

1952

Becomes professor at Shizuoka Prefectural Women's Junior College.

1953

The Konohanakai holds its first exhibition at Takashimaya Department Store.

1955

Establishes the Serizawa Paper-Dyeing Research Institute (see cat. 16) as a limited company.

1956

Appointed Holder of an Important Intangible Cultural Property, or Living National Treasure. Builds a new workshop.

1957

Moves a traditional clapboard storehouse from Ishikoshi, Miyagi Prefecture, to Kamata. Rents a farmhouse near Tsumura outside Kamakura and makes it his private studio (see cat. 69).

1958

Takes part in work on the Ohara Museum of Art in Okayama Prefecture, planning the repositioning of the storehouses making up the museum and designing the interior and exterior decoration and exhibition furniture. Travels to Okinawa at the invitation of the International Crafts Federation and holds a one-man exhibition on the premises of *Okinawa taimusu* (Okinawa Times). (Makes further visits to Okinawa in 1964, 1965, 1968, and 1970.)

1960

Yanagi Muneyoshi visits his studio at Tsumura while returning to Tokyo from the Matsugaoka Bunko Library.

1961

Yanagi Muneyoshi dies. Serizawa is deeply affected by his death and helps with the funeral arrangements. The Ceramic Gallery at the Ohara Museum of Art is completed, showing work by Bernard Leach, Tomimoto Kenkichi, Kawai Kenjirō, and Hamada Shōji.

1962

Serizawa meets Martha W. Longenecker, future founder of the Mingei International Museum, at the memorial service for Yanagi Muneyoshi at Kōyasan.

1963

The Print and Textile Gallery at the Ohara Museum is completed, showing work by Munakata Shikō and Serizawa.

1966

Visits the Cataluña Museum in Barcelona and travels to Egypt, Turkey, Italy, France, and other countries. Receives the Purple Ribbon Medal from the Japanese government.

1967

Publishes the first volume of *Jisen Serisawa Keisuke sakuhinshū* (The Works of Serizawa Keisuke, Selected by the Author) and *Kataezome* (Stencil Dyeing). Awarded the Freedom of the City of Shizuoka.

1968

Invited to teach a summer seminar at San Diego State University, holding exhibitions both there and in Vancouver and Los Angeles.

1969

Publishes *Serizawa Keisuke tebikae-chō* (The Notebooks of Serizawa Keisuke). Holds an exhibition at the Tanakaya Department Store, Shizuoka City, to celebrate the city's eightieth anniversary.

1970

Receives the Order of the Sacred Treasure, Fourth Class, from the Japanese government.

1971

A Serizawa Keisuke Glass Painting Exhibition is held at Matsuya Department Store, Ginza, Tokyo, and the Nihon Mingeikan hosts the exhibition *Serizawa Keisuke shūshūhin* (The Personal Collection of Serizawa Keisuke). Jean Leymarie, director of the National Gallery of Modern Art in Paris, visits Tokyo and asks Serizawa to hold an exhibition in the French capital.

1972

Travels to France to design the interior decoration for Jun restaurant but suffers a heart attack during his visit and spends two months in the hospital before returning to Japan. Publishes *Hariko Iroiro* (Papier-Mâché Toys; see cat. 85).

1973

The exhibition *Serizawa Keisuke — hito to shigoto* (Serizawa Keisuke: The Man and His Work) is held at the Hankyu Department Store, Osaka, under the sponsorship of the *Asahi Shimbun* newspaper.

1974

Designs a ceremonial curtain for the main hall of the Chion'in temple, Kyoto.

1976

The Serizawa exhibition is held at the Grand Palais, Paris (to February 1977). Appointed Bunka Kōrōsha (Member of the Order of Cultural Merit) by the Japanese government.

1977

Serizawa Keisuke exhibition held at the Suntory Museum of Art.

1978

The exhibition *Sekai no some to ori — Serizawa Keisuke no shinpen* (Dyeing and Weaving from Around the Globe: The World of Serizawa Keisuke) is held at Hamamatsu City Art Museum and another exhibition, *Serizawa Keisuke no shūshū — mō hitotsu no sōzō* (Serizawa Keisuke's Collection: Another Facet of His Creative Work) is held at the Ohara Museum of Art.

1979

A Serizawa Keisuke exhibition is held at the Mingei International Museum, La Jolla, California, and the exhibition *Serizawa Keisuke — sono sōzō no subete* (The Complete Creative Work of Serizawa Keisuke) is held at Chiba Prefectural Museum of Art.

1981

The Shizuoka Municipal Serizawa Keisuke Art Museum opens on June 15.

1982

The exhibition *Serizawa Keisuke no moji* (Letters and Characters in the Art of Serizawa Keisuke) is held at the Tochigi Prefecture Ashikaga Library. Designs *Ten Great Disciples of the Buddha* for the main hall of the Syakamuni Temple at Kushinagara, India, the site of the historical Buddha's final enlightenment.

1983

The French government appoints Serizawa Officier de l'Ordre des Arts et des Lettres. The last volume of *Serizawa Keisuke zenshū* (The Complete Works of Serizawa Keisuke) is published by Chūōkōronsha and the exhibition *Hachijūhachi-sō Serizawa Keisuke sakuhinshū* (A Collection of Works by Serizawa Keisuke in Celebration of His Eighty-Eighth Birthday) is held at Keio Department Store, Shinjuku, Tokyo. On August 19, Serizawa collapses at his home in Kamata and is taken to the hospital.

1984

Dies from heart failure on April 5.

Friends of Japan Society Gallery

HONORARY CHAIR
Her Imperial Highness
Princess Takamado

CO-CHAIRS
Margot Paul Ernst
Masako Shinn

DIRECTOR'S CIRCLE
Diane and Arthur Abbey
Edward and Betsy Cohen
Henry and Vanessa Cornell
Kurt A. Gitter, M.D., and Alice Yelen
Sebastian and Miki Izzard
Edward and Anne Studzinski
Yasko Tashiro and Thierry Porté
Chris A. Wachenheim
Jack and Susy Wadsworth

GALLERY CIRCLE
Shin and Maho Abe
Dr. and Mrs. Frederick Baekeland
Marc and Sara Benda
Raphael Bernstein
Japanese Art Department, Bonhams
 North America
Marguerite and Walter Bopp
Rosemarie Bria and Sandy Levine
Henry and Gilda Buchbinder
Mary Griggs Burke
Beatrice Lei Chang
Dr. Carmel and Babette Cohen
Pilar Conde and Alfonso Lledo-Perez
Charles T. Danziger
Peggy and Richard M. Danziger
Thomas Danziger and
 Laura B. Whitman
Georgia and Michael de Havenon
Judith Dowling
Joe Earle and Charlotte Knox
The Esther Simon Charitable Trust
Martin and Kathleen Feldstein
Tom and Jody Gill
Alan and Simone Hartman
Mrs. Seiji Hatakeyama
Yūko Hosomi and Kōichi Yanagi
Tomi Ise
Machiko Kashiwagi and
 Thomas Bingham
Mark and Elizabeth Levine

Dr. Stephen and Michiko Levine
Rosemarie and Leighton R. Longhi
Dr. and Mrs. Robert W. Lyons
Mika Gallery
Joan B. Mirviss
Klaus F. Naumann
Marjorie G. Neuwirth
Halsey and Alice North
Wakako Ohara
Alex B. Pagel
Shelly and Lester Richter
Diane H. Schafer and
 Dr. Jeffrey A. Stein
Fredric T. Schneider
Lea Sneider
Mary Ann and Stanley Snider
Erik and Cornelia Thomsen
Sachiko Tsuchiya
Mr. and Mrs. Cor van den Heuvel
Marie-Helene Weill
Roger L. Weston
Richard and Judy Wood
Katsura and Mayo Yamaguchi
Anonymous (6)

いろはにほへと ちりぬるをわかよた れそつねならむ うゐのおくやまけ ふこえてあさきめ あさしゑひもせす